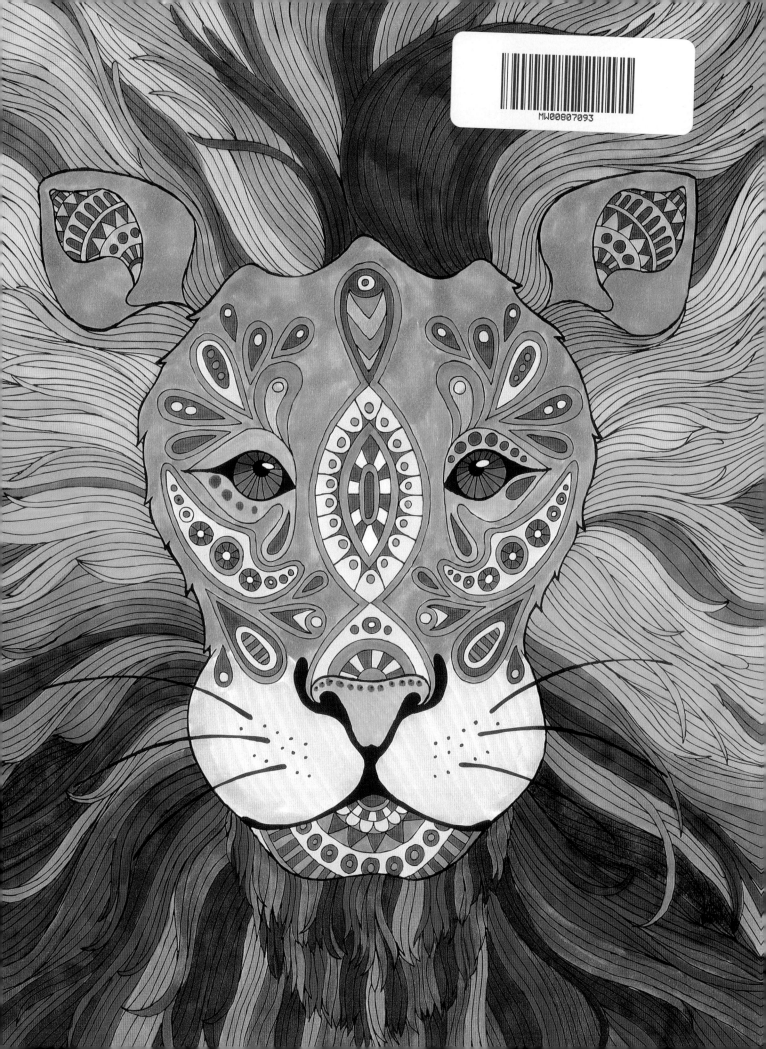

What's My Style?

I love creating elaborate patterns packed with detail so I can do lots of intricate coloring. I try to use as many colors as possible. Then I layer on lots of fun details. Here are some more examples of my work.

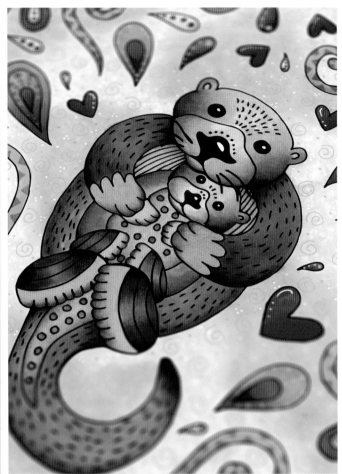

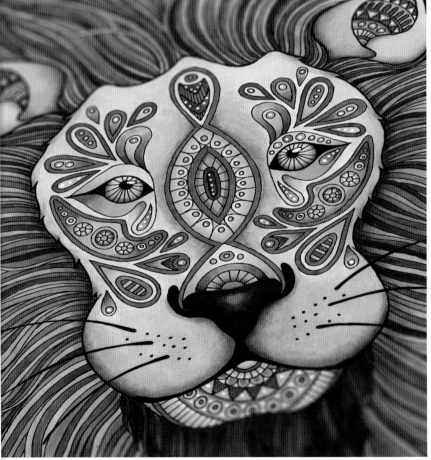

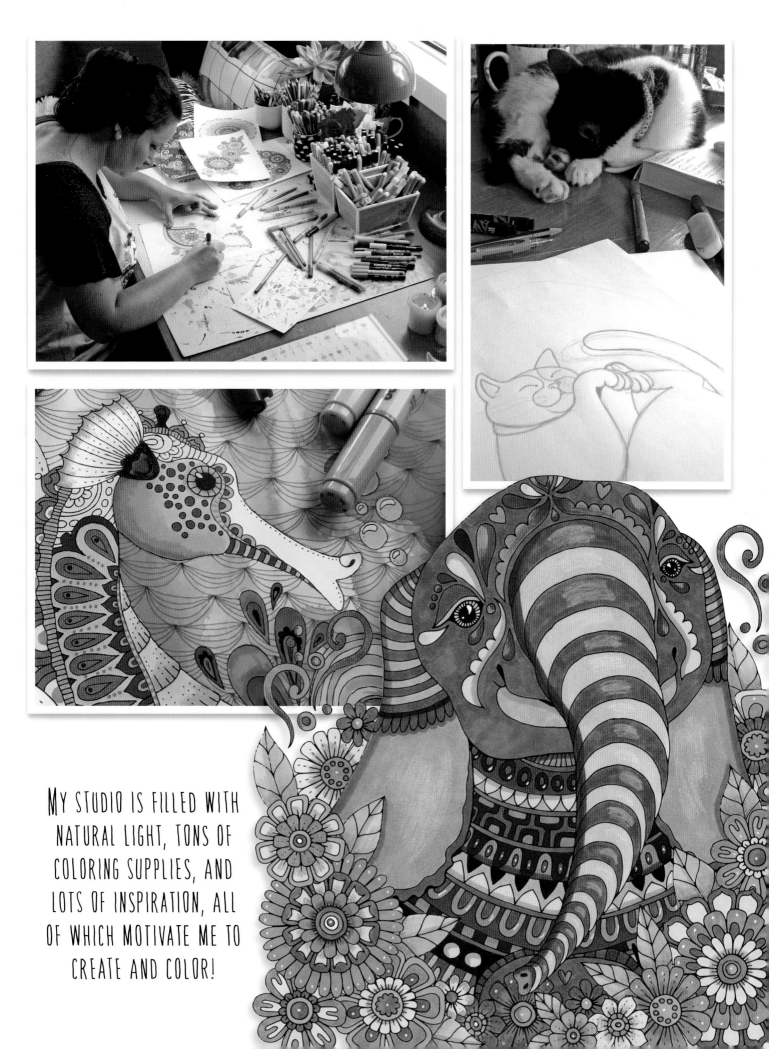

My studio is filled with natural light, tons of coloring supplies, and lots of inspiration, all of which motivate me to create and color!

Where to Start

You might find putting color on a fresh page stressful. It's okay! Here are a few tricks I use to get the ink flowing.

Start with an easy decision. If a design has leaves, without a doubt, that's where I start. No matter how wacky and colorful everything else gets, I always color the leaves in my illustrations green. I have no reason for it; it's just how it is! Try to find something in the design to help ground you by making an easy color decision: leaves are green, the sky is blue, etc.

Get inspired. Take a good look at everything in the illustration. You chose to color it for a reason. One little piece that you love will jump out and say, "Color me! Use red, please!" Or maybe it will say blue, or pink, or green. Just relax—it will let you know.

Follow your instincts. What colors do you love? Are you a big fan of purple? Or maybe yellow is your favorite. If you love it, use it!

Just go for it. Close your eyes, pick up a color, point to a spot on the illustration, and start! Sometimes starting is the hardest part, but it's the fastest way to finish!

Helpful Hints

There is no right or wrong. All colors work together, so don't be scared to mix it up. The results can be surprising!

Try it. Test your chosen colors on scrap paper before you start coloring your design. You can also test blending techniques and how to use different shapes and patterns for detail work—you can see how different media will blend with or show up on top of your chosen colors. I even use the paper to clean my markers or pens if necessary.

Make a color chart. A color chart is like a test paper for every single color you have! It provides a more accurate way to choose colors than selecting them based on the color of the marker's cap. To make a color chart, color a swatch with each marker, colored pencil, gel pen, etc. Label each swatch with the name or number of the marker so you can easily find it later.

Do you like warm colors?

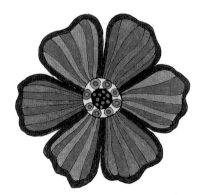

How about cool colors?

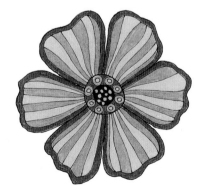

Maybe you like warm and cool colors together!

Keep going. Even if you think you've ruined a piece, work through it. I go through the same cycle with my coloring: I love a piece at the beginning, and by the halfway point I nearly always dislike it. Sometimes by the end I love it again, and sometimes I don't, and that's okay. It's important to remember that you're coloring for you—no one else. If you really don't like a piece at the end, stash it away and remember that you learned something. You know what not to do next time. My studio drawers are full of everything from duds to masterpieces!

Be patient. Let markers, gel pens, and paints dry thoroughly between each layer. There's nothing worse than smudging a cluster of freshly inked dots across the page with your hand. Just give them a minute to dry and then you can move on to the next layer.

Use caution. Juicy/inky markers can "spit" when you uncap them. Open them away from your art piece.

Work from light to dark. It's much easier to make something darker gradually than to lighten it.

Shade with gray. A mid-tone lavender-gray marker is perfect for adding shadows to your artwork, giving it depth and making it pop right off the page!

Try blending fluid. If you like working with alcohol-based markers, a refillable bottle of blending fluid or a blending pen is a great investment. Aside from enabling you to easily blend colors together, it can help clean up unwanted splatters or mistakes—it may not take some colors away completely, but it will certainly lighten them. I use it to clean the body of my markers as I'm constantly smudging them with inky fingers. When a marker is running out of ink, I find adding a few drops of blending fluid to the ink barrel will make it last a bit longer.

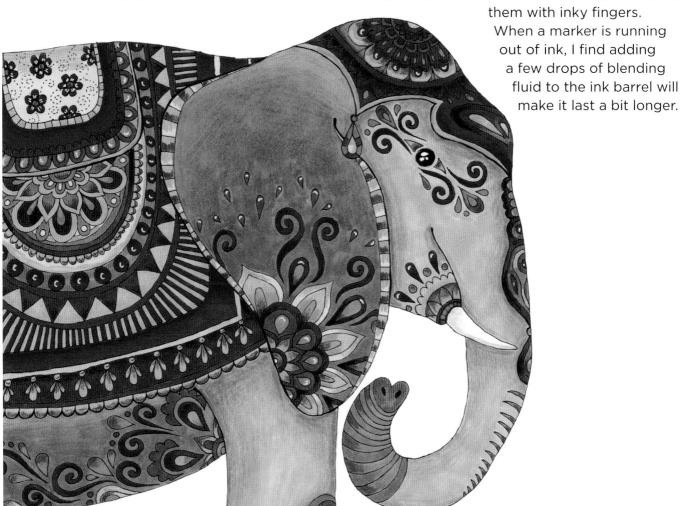

Layering and Blending

I love layering and blending colors. It's a great way to create shading and give your finished piece lots of depth and dimension. The trick is to work from the lightest color to the darkest and then go over everything again with the lightest shade to keep the color smooth and bring all the layers together.

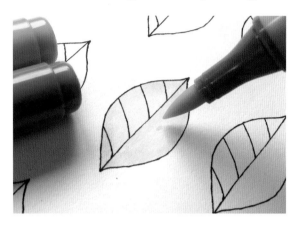

1 Apply a base layer with the lightest color.

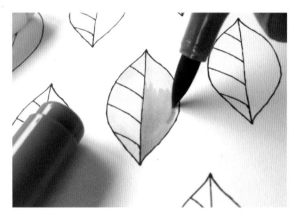

2 Add the middle color, using it to create shading.

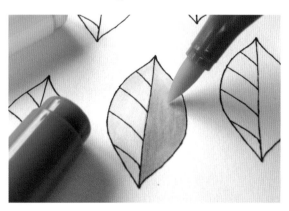

3 Smooth out the color by going over everything with the lightest color.

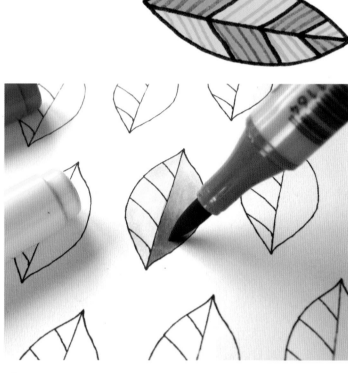

4 Add the darkest color, giving your shading even more depth. Use the middle color to go over the same area you colored in Step 2.

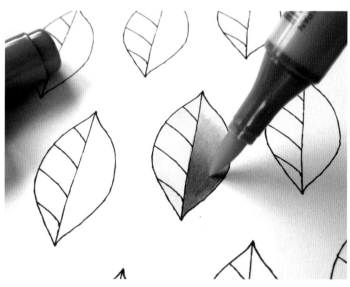

5 Go over everything with the lightest color as you did in Step 3.

Patterning and Details

Layering and blending will give your coloring depth and dimension. Adding patterning and details will really bring it to life. If you're not convinced, try adding a few details to one of your colored pieces with a white gel pen—that baby will make magic happen! Have fun adding all of the dots, doodles, and swirls you can imagine.

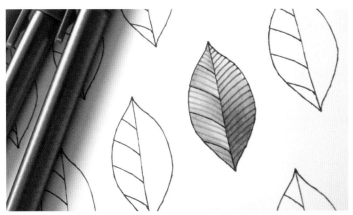

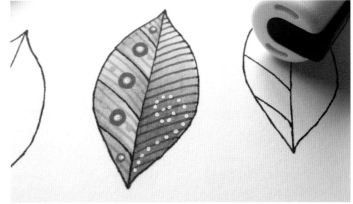

1 Once you've finished your coloring, blending, and layering, go back and add simple patterning like lines or dots. You can add your patterns in black or color. For this leaf, I used two different shades of green pen.

2 Now it's time to add some fun details using paint pens or gel pens. Here I used white, yellow, and more green.

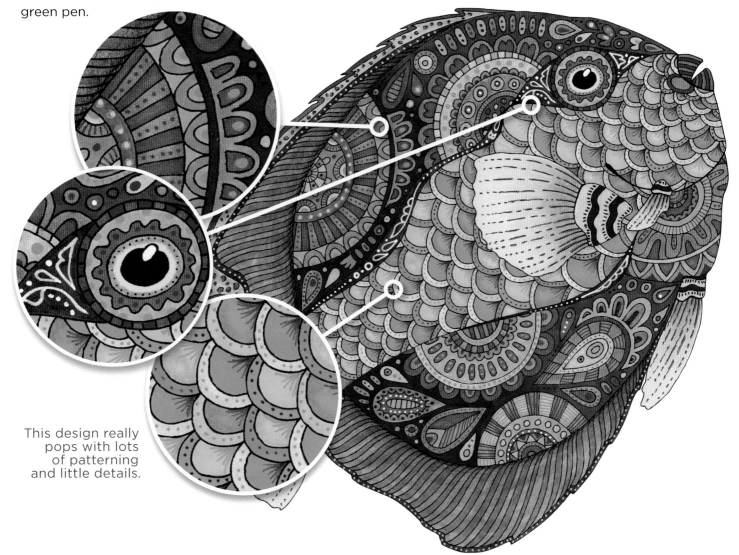

This design really pops with lots of patterning and little details.

Coloring Supplies

I'm always asked about the mediums I use to color my illustrations. The answer would be really long if I listed every single thing, so here are a few of my favorites. Keep in mind that these are *my* favorites. When you color, you should use YOUR favorites!

Alcohol-based markers. I have many, and a variety of brands. My favorites have a brush nib—it's so versatile. A brush nib is perfect for tiny, tight corners, but is also able to cover a large, open space easily. I find I rarely get streaking, and if I do, it's usually because the ink is running low!

Fine-tip pens. Just like with markers, I have lots of different pens. I use them for my layers of detail work and for the itsy bitsy spots my markers can't get into.

Paint pens. These are wonderful! Because the ink is usually opaque, they stand out really well against a dark base color. I use extra fine point pens for their precision. Some paint pens are water based, so I can use a brush to blend the colors and create a cool watercolor effect.

Gel pens. I have a few, but I usually stick to white and neon colors that will stand out on top of dark base colors or other mediums.

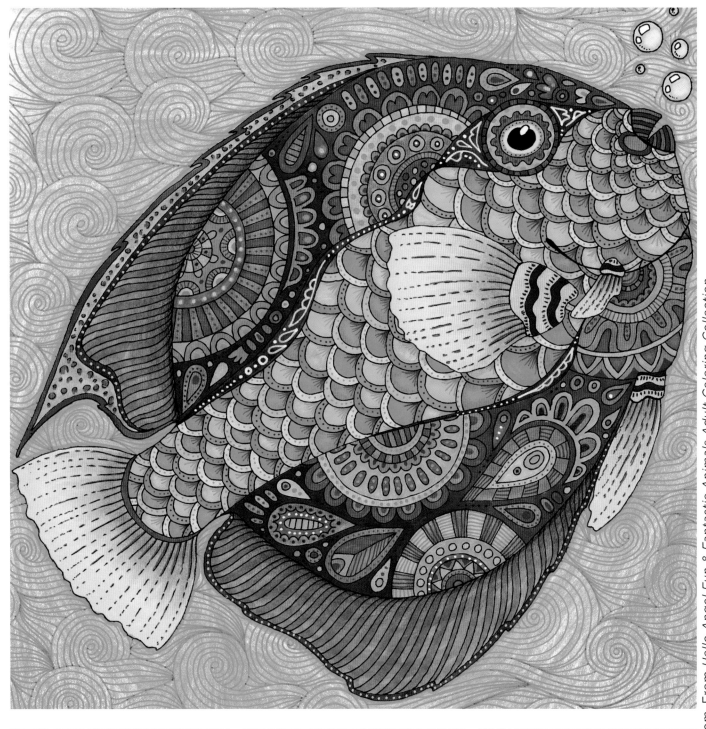

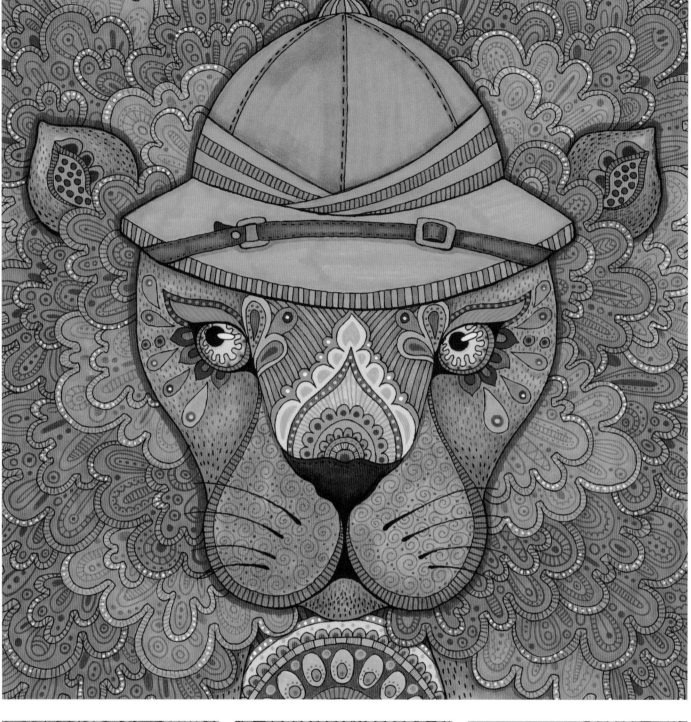

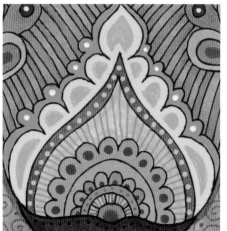

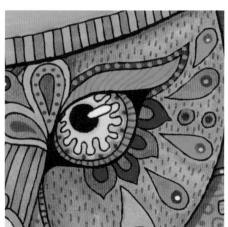

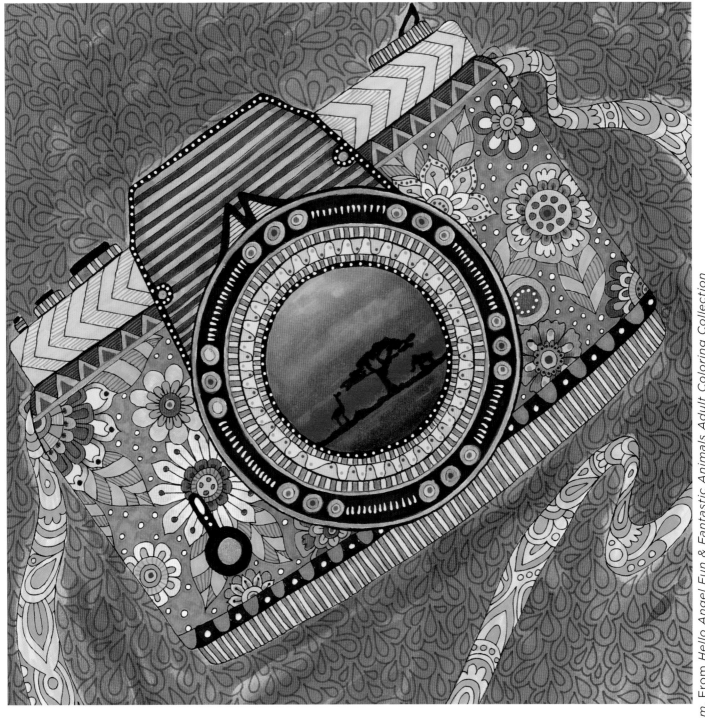

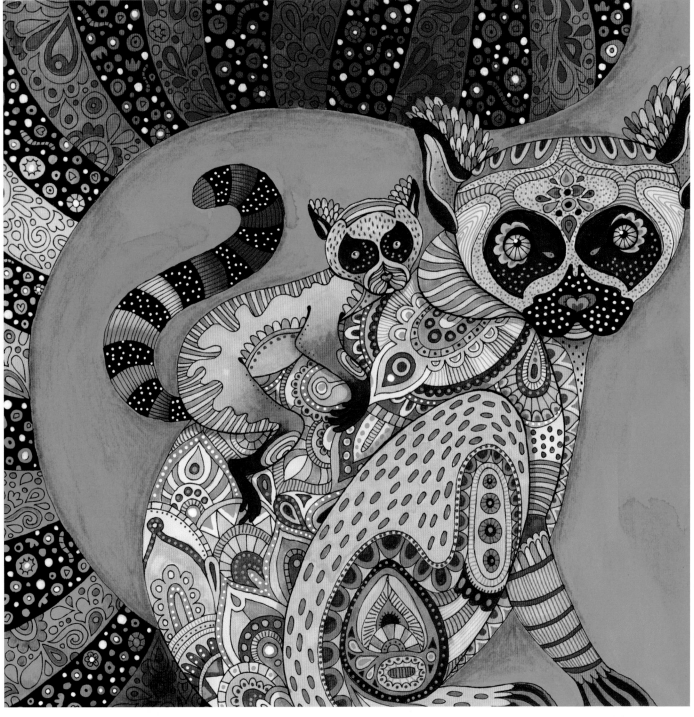

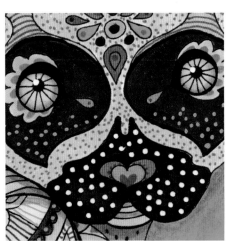

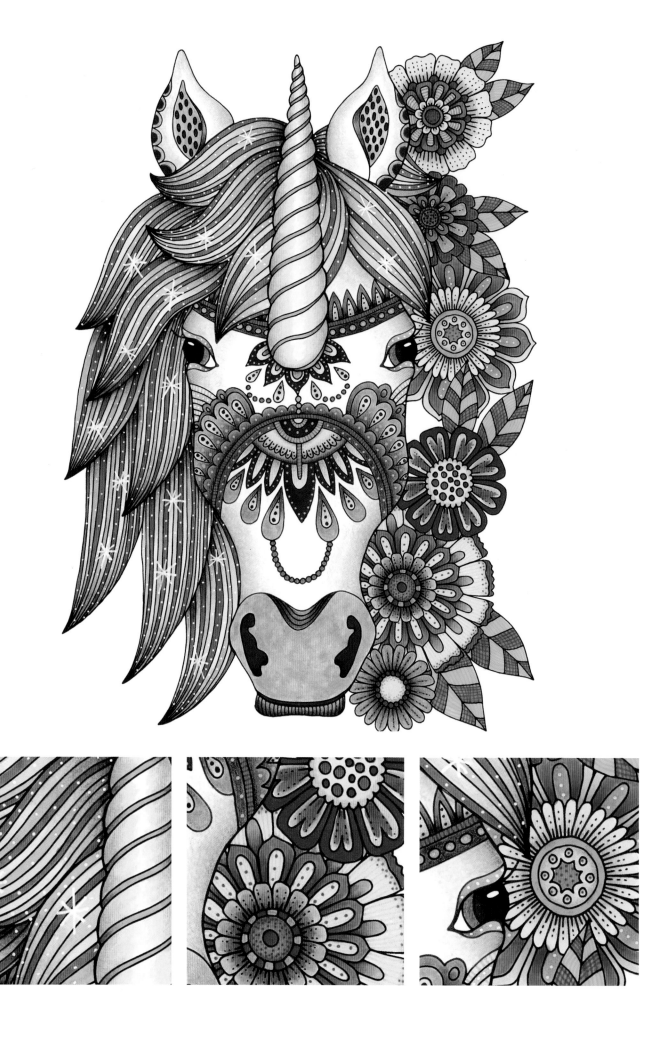

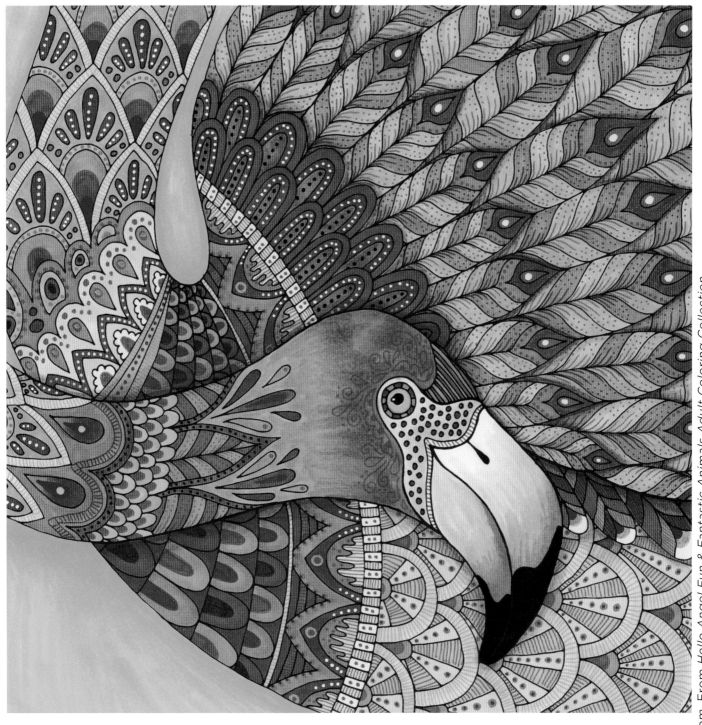

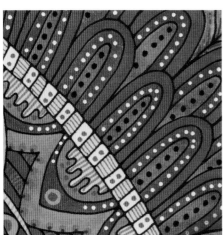

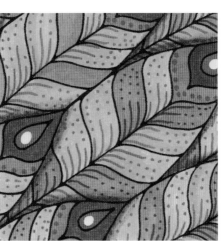

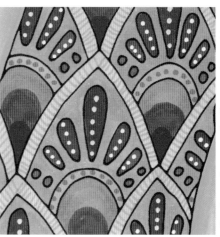

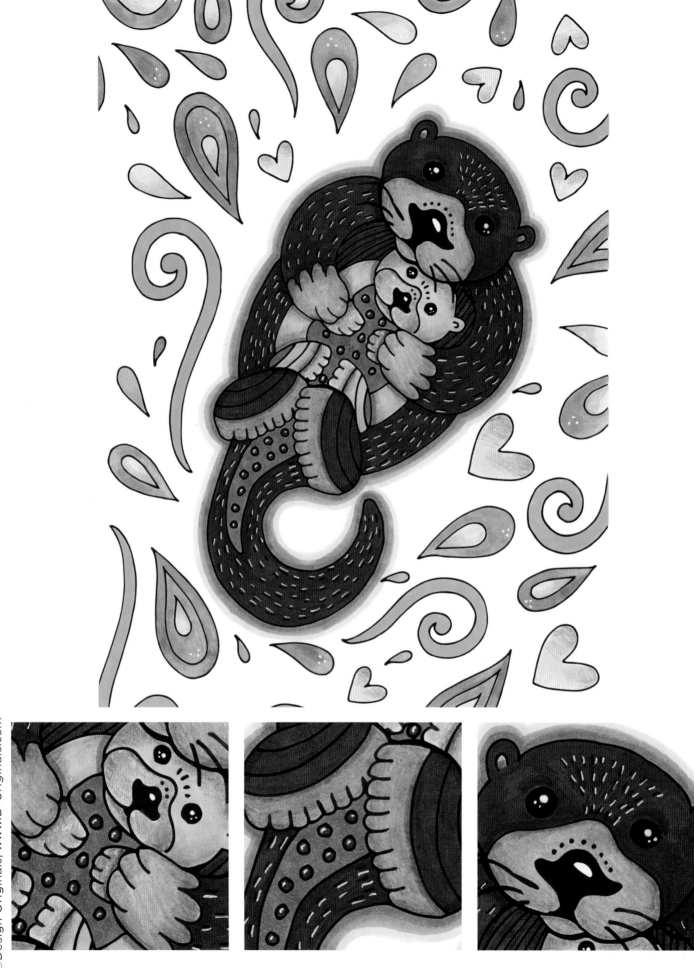

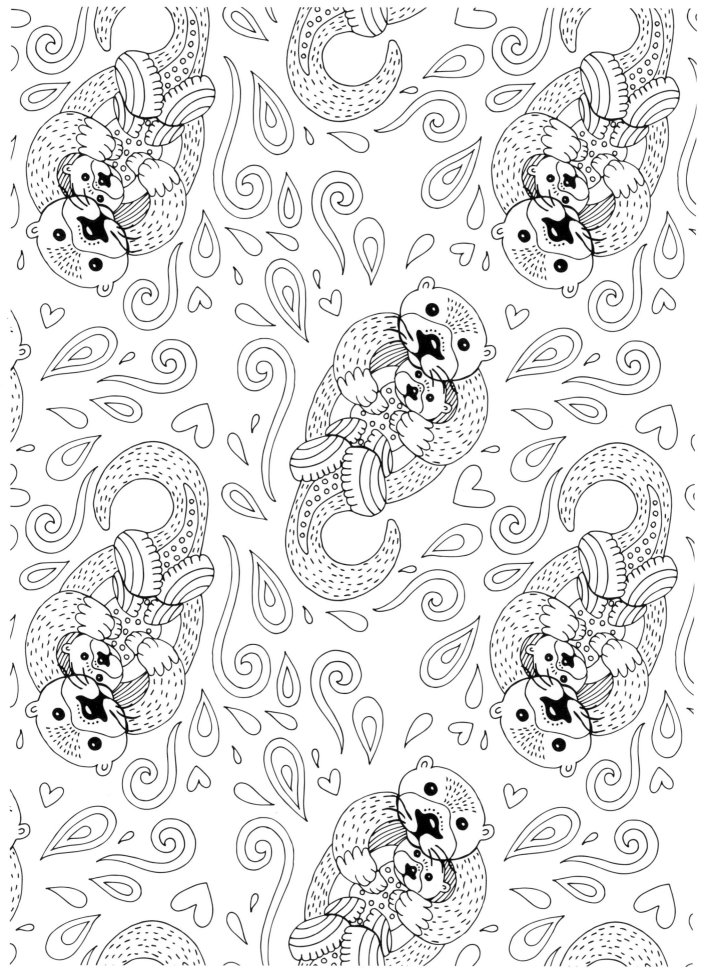

"When the mind is pure,
joy follows like a shadow
that never leaves."

—BUDDHA

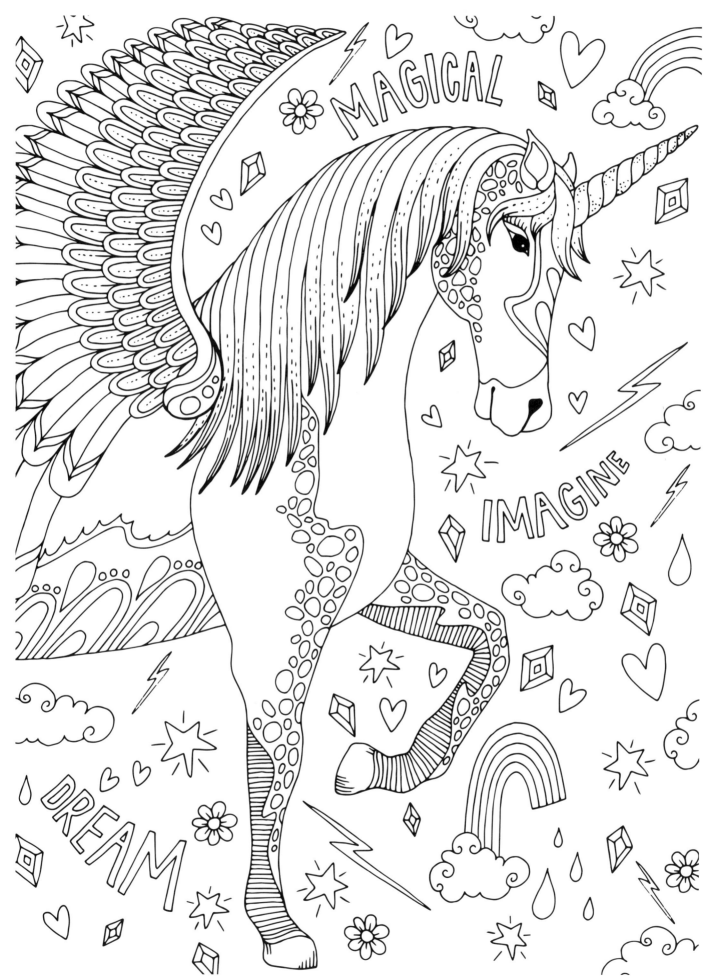

"You can't do it unless
you can imagine it."

—GEORGE LUCAS

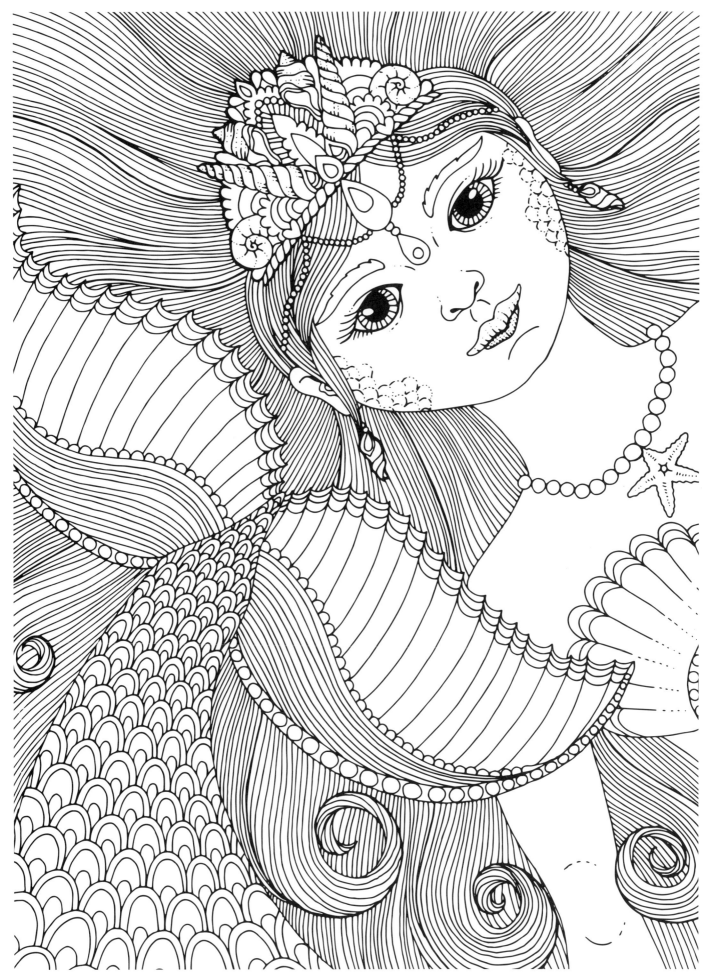

"I'm youth, I'm joy,
I'm a little bird that has
broken out of the egg."

—JAMES M. BARRIE

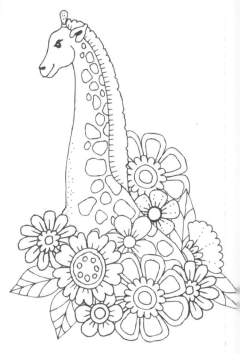

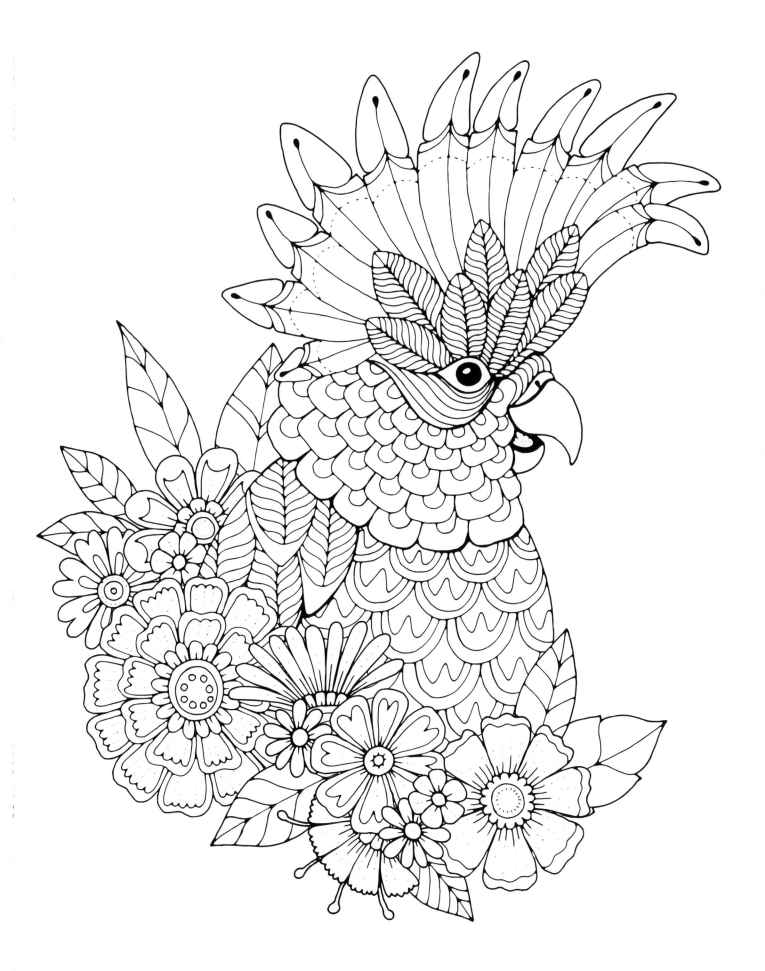

"Our thoughts and imagination
are the only real limits to our possibilities."

—ORISON SWETT MARDEN

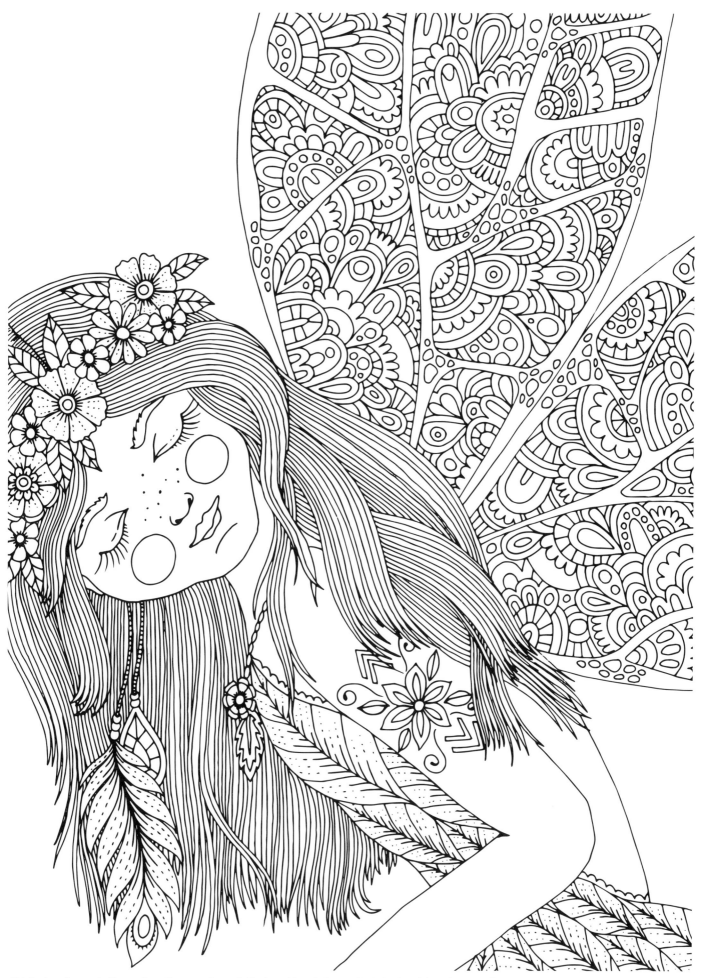

"Be happy for this moment.
This moment is your life."

—OMAR KHAYYAM

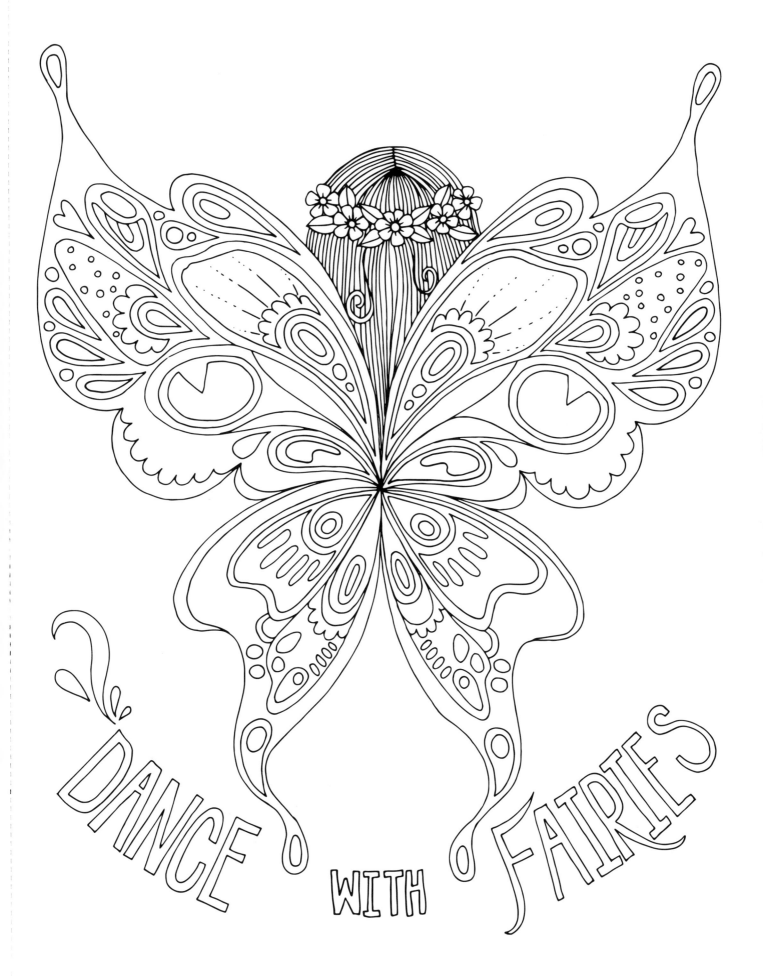

"Creativity is a mansion.
If you're empty in one room,
all you have to do is go out into the hallway
and enter another room that's full."

—F. GARY GRAY

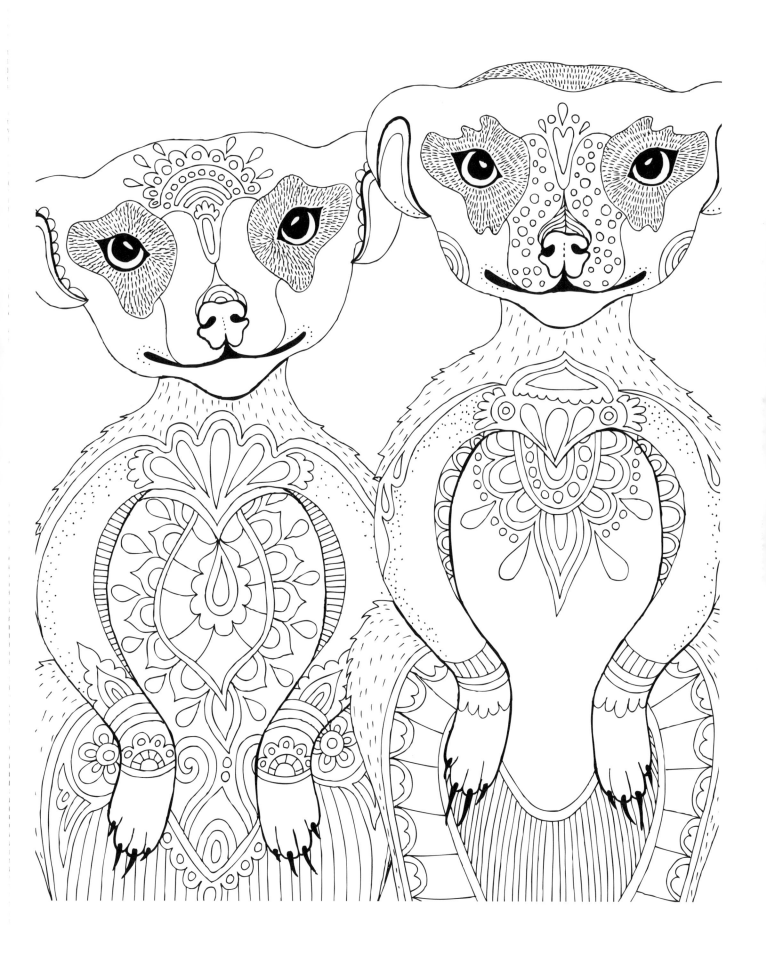

"A work of art is a world in itself
reflecting senses and emotions
of the artist's world."

—HANS HOFMANN

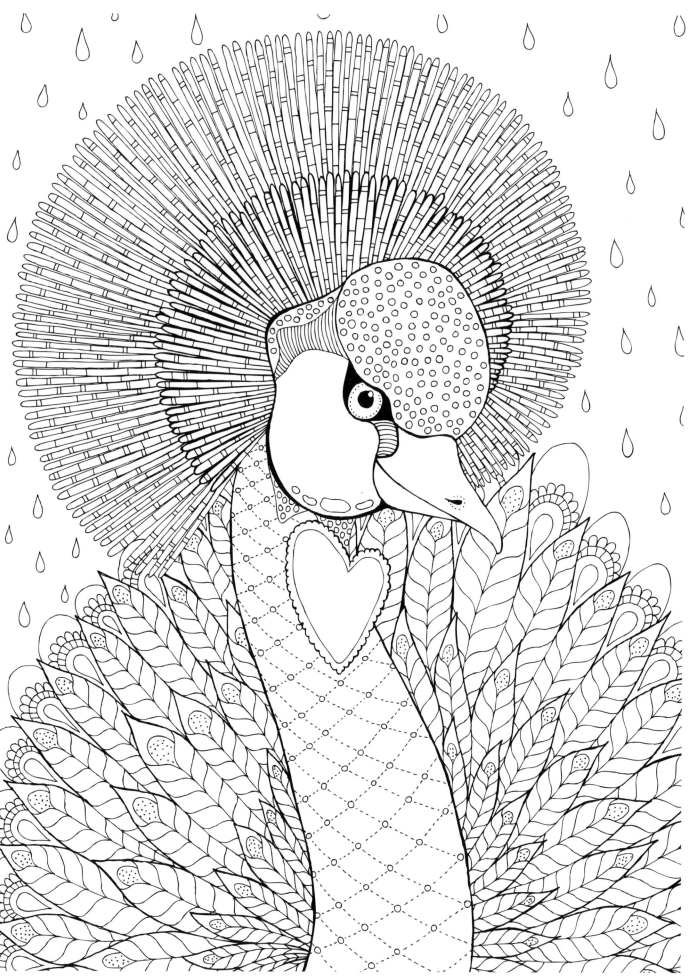

"Imagination is the eye of the soul."

—JOSEPH JOUBERT

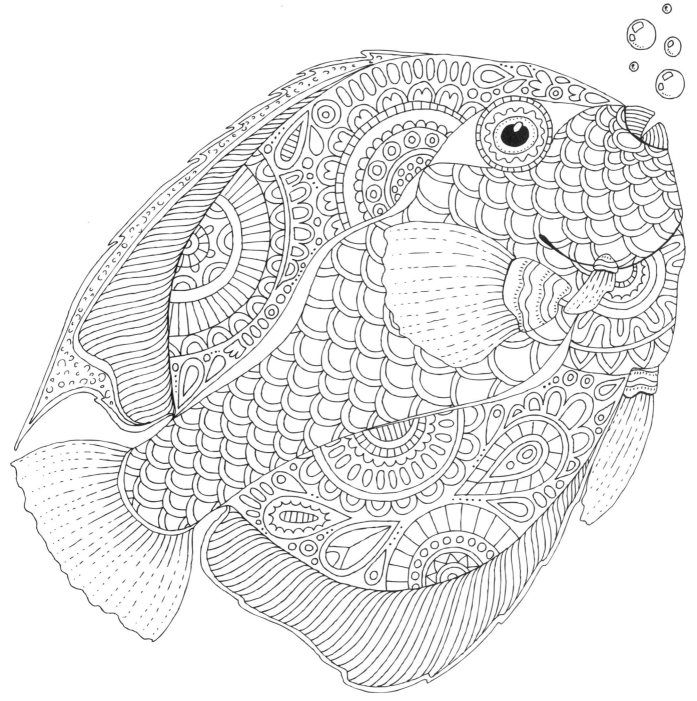

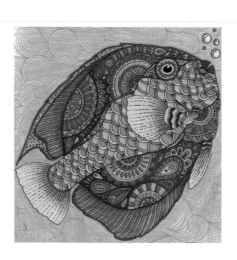

Having a plan helps: see how an analogous scheme of blues and greens works perfectly for the scales?

"Fantasy is hardly an escape from reality.
It's a way of understanding it."

—LLOYD ALEXANDER

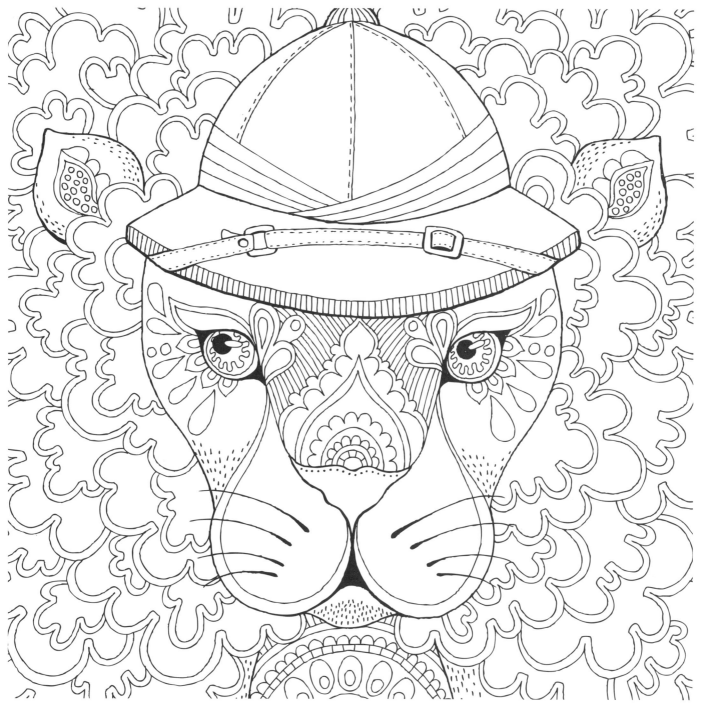

Think like a makeup artist: use cool feature highlights against a warm, monochromatic mane, and you'll end up with a glam-rockin' safari lion!

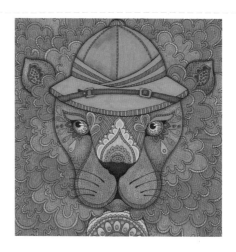

"Enjoy the journey and try to get better every day. And don't lose the passion and the love for what you do."

—Nadia Comaneci

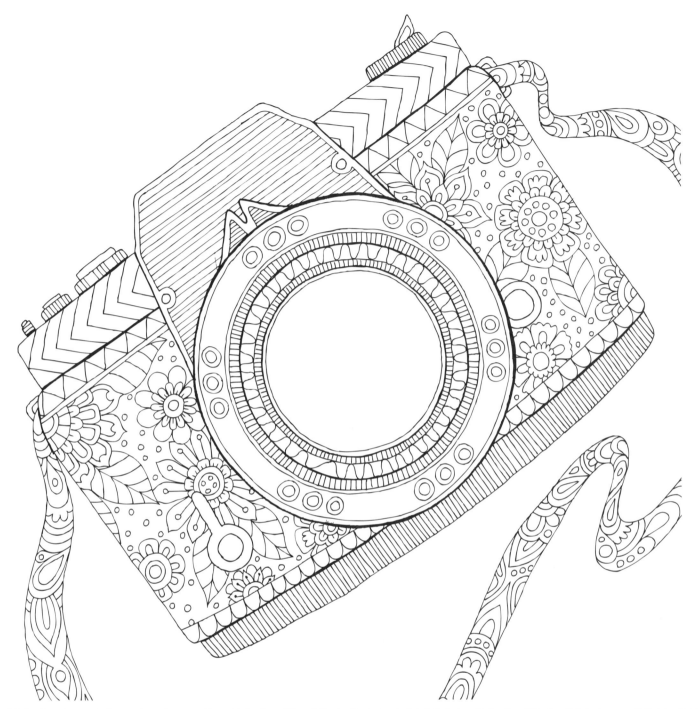

A flat background pumped full of electric color turns
any ordinary coloring into a showstopper.

"Creativity is piercing
the mundane to
find the marvelous."

—Bill Moyers

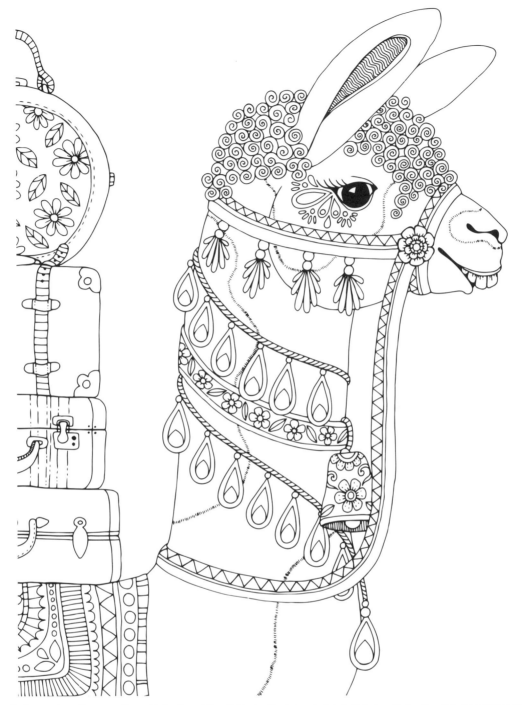

This character looks ready to go somewhere fancy—
what are your most showoffy colors?

"Draw your pleasure,
paint your pleasure,
and express your
pleasure strongly."

—Pierre Bonnard

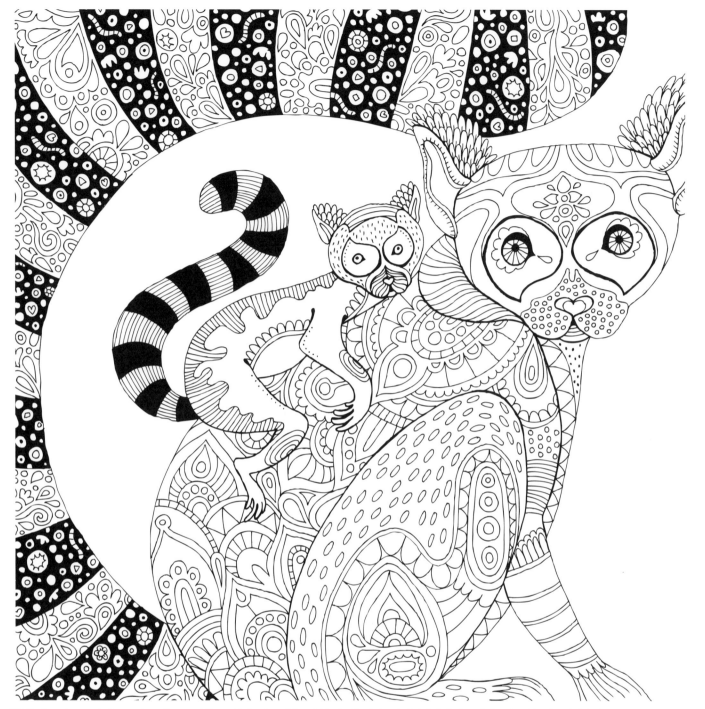

Like parent, like child! Make a statement with one tail, and then emphasize it by replicating your color pattern in the other tail.

"Creativity flows when curiosity is stoked."

—Neil Blumenthal

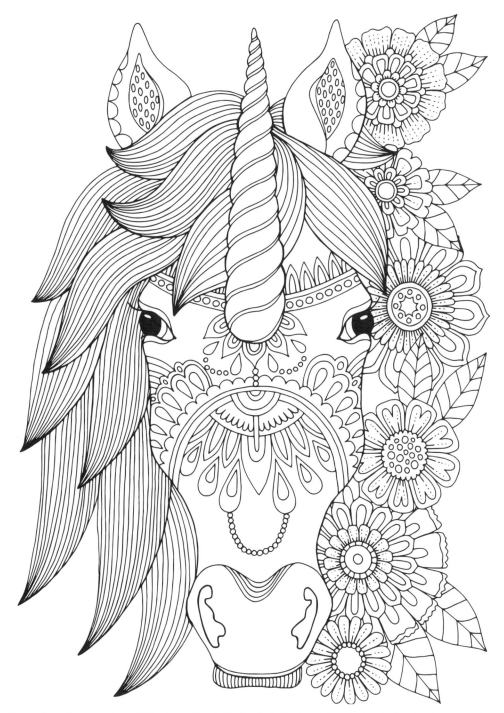

Purple is the color of royalty (which the unicorn definitely is!).
And what complements purple better than gold?

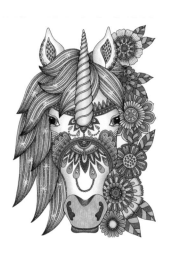

"You might not make it to the top,
but if you are doing what you love,
there is much more happiness there
than being rich or famous."

—TONY HAWK

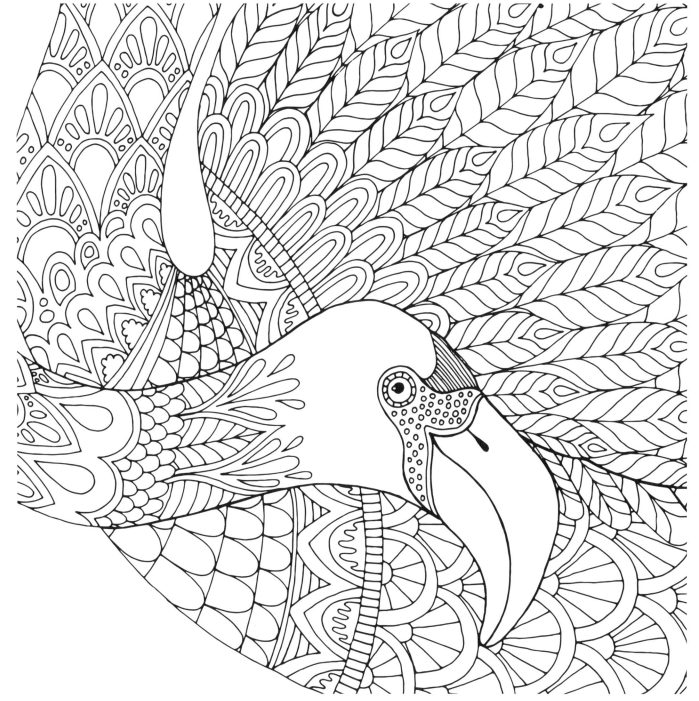

Stack shades and tints of the same color to make
this flamingo utterly beautiful.

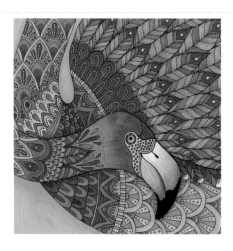

"People discuss my art and
pretend to understand as if it
were necessary to understand,
when it's simply necessary to love."

—CLAUDE MONET

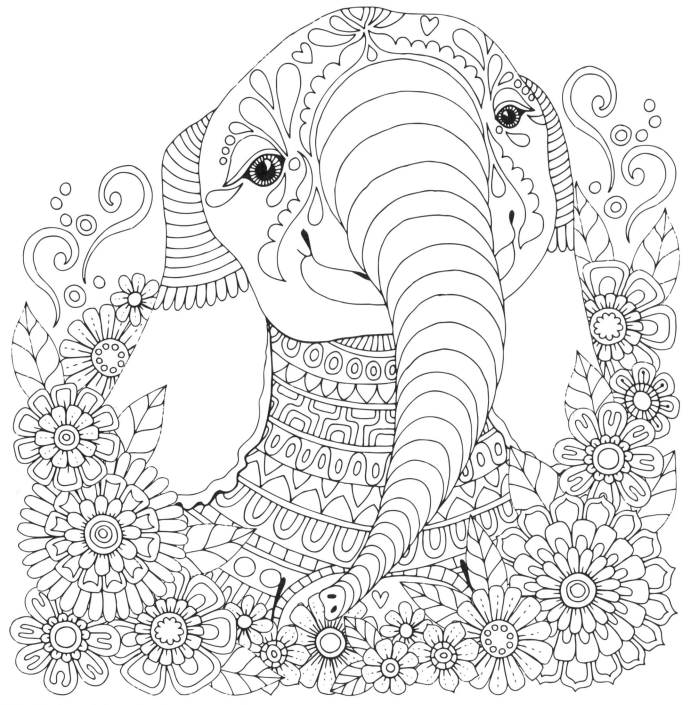

Sometimes shades close in temperature to each other, like the two shades of blue on the trunk, make a striking impression.

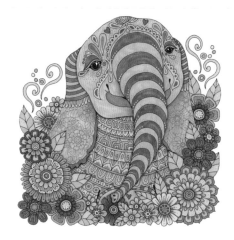

"Be silly. You're allowed to be silly.
There's nothing wrong with it."

—JIMMY FALLON

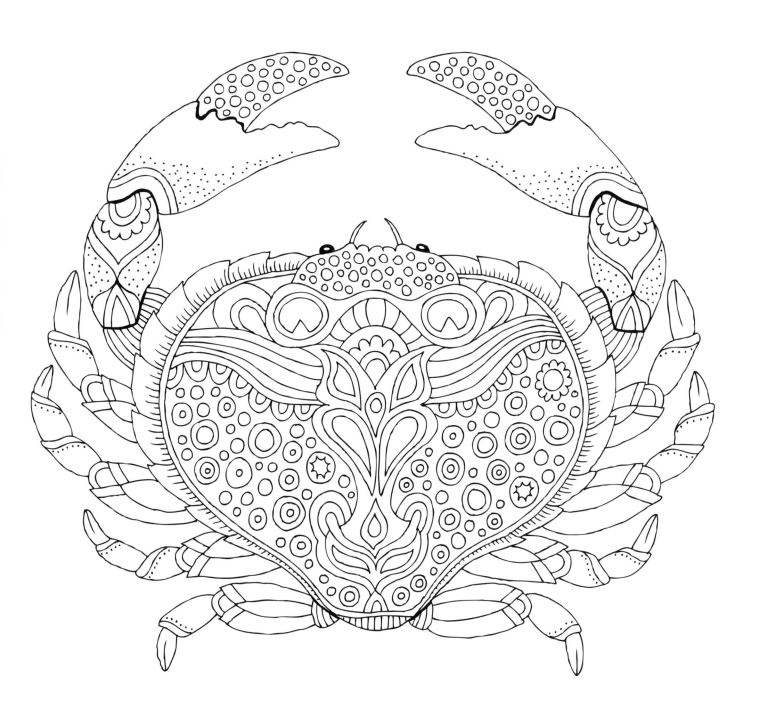

"Joy is the serious business of Heaven."

—C.S. Lewis

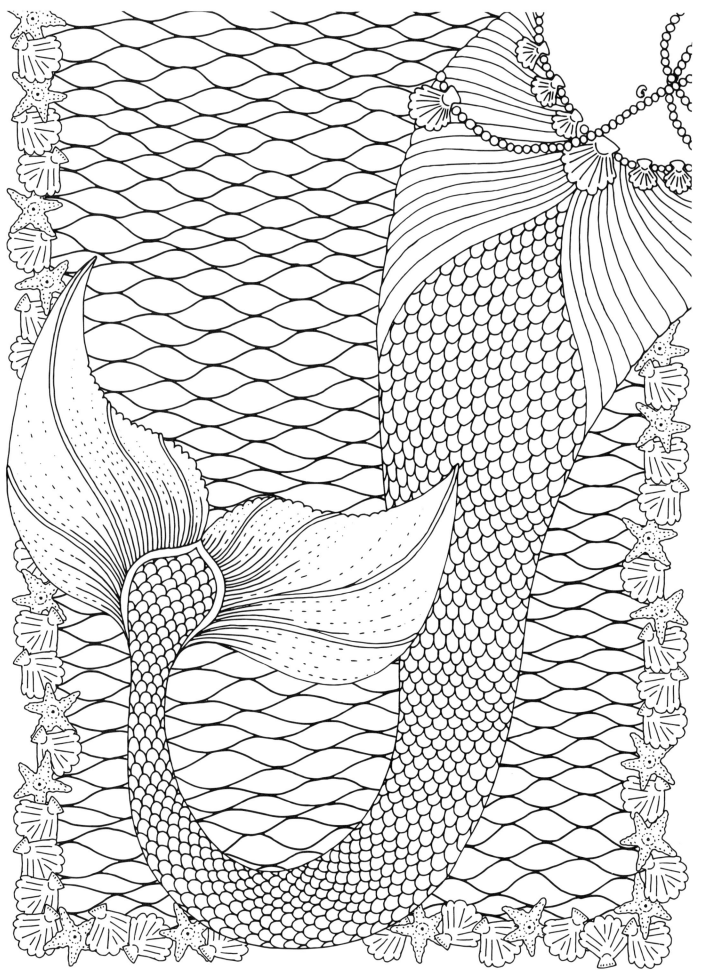

"Creativity is a spark. It can be excruciating when we're rubbing two rocks together and getting nothing. And it can be intensely satisfying when the flame catches and a new idea sweeps around the world."

—JONAH LEHRER

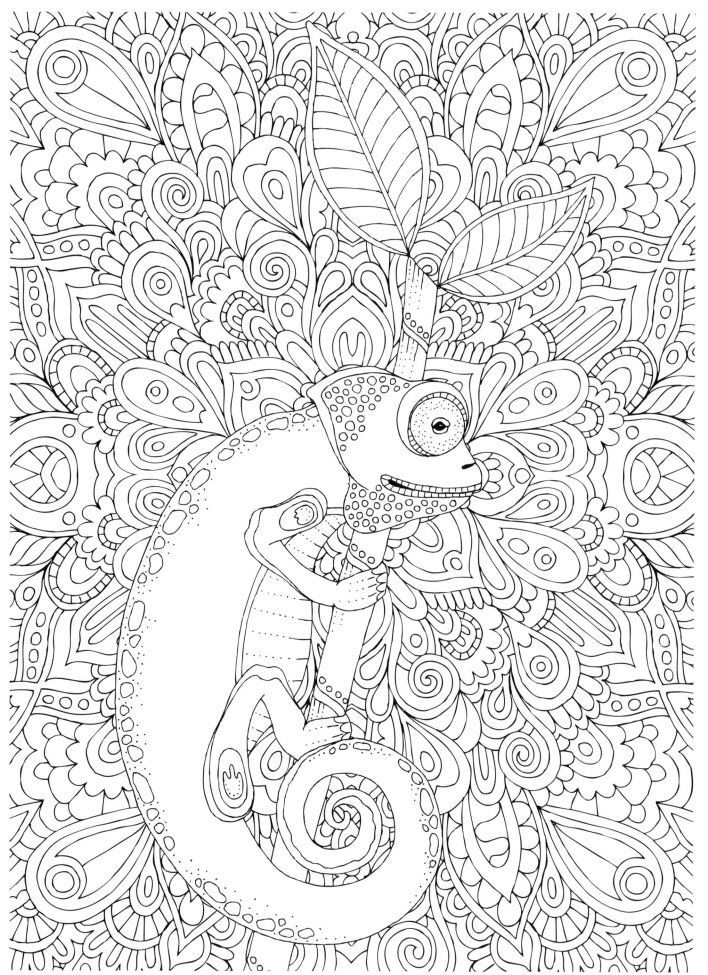

"There is no such thing
as the pursuit of happiness,
but there is the discovery of joy."

—JOYCE GRENFELL

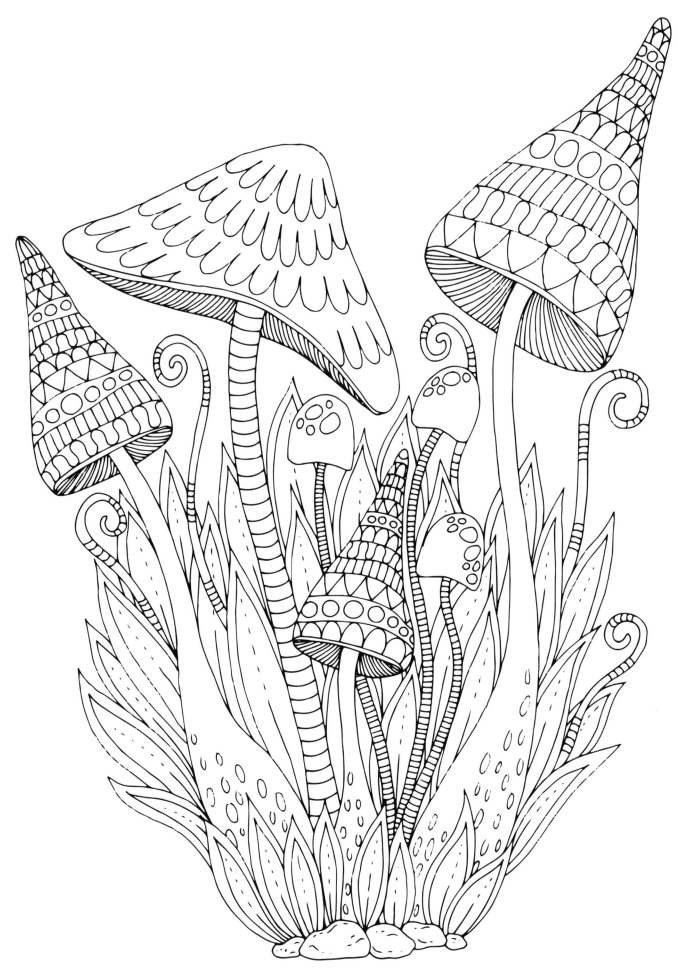

"The most simple things
can bring the most happiness."

—Izabella Scorupco

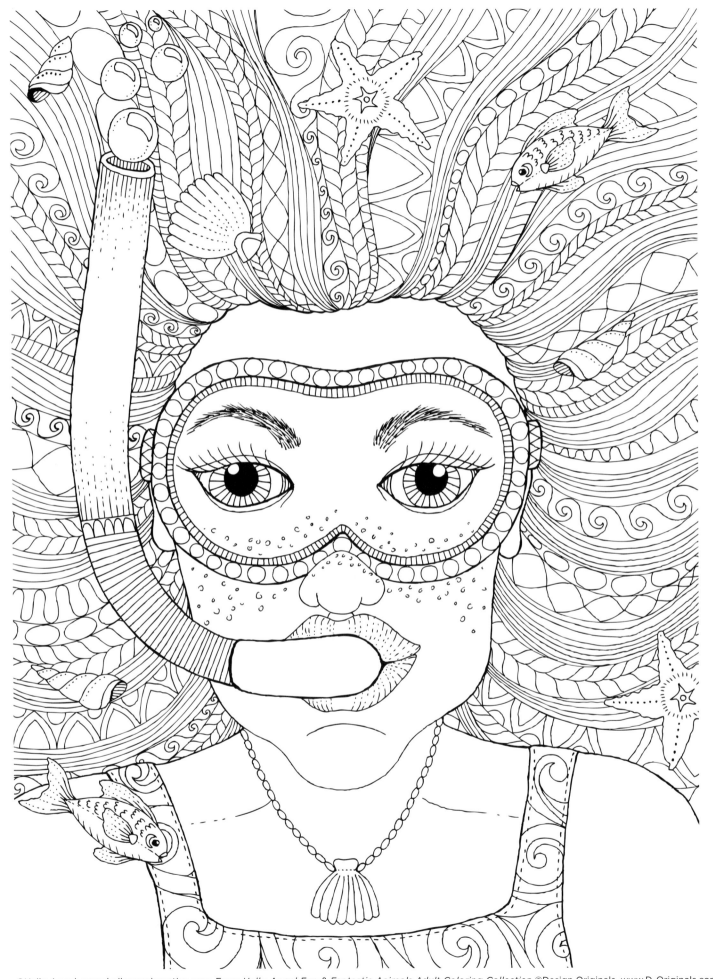

"The most beautiful thing
we can experience is the mysterious.
It is the source of all true art and science."

—ALBERT EINSTEIN

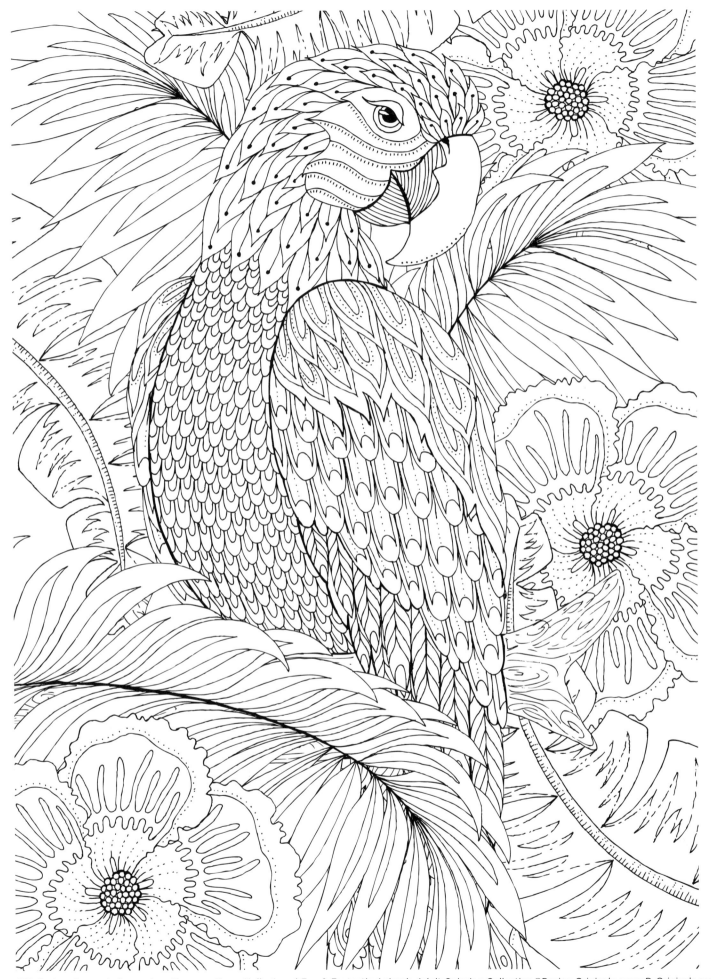

"Creativity is always a leap of faith.
You're faced with a blank page,
blank easel, or an empty stage."

—Julia Cameron

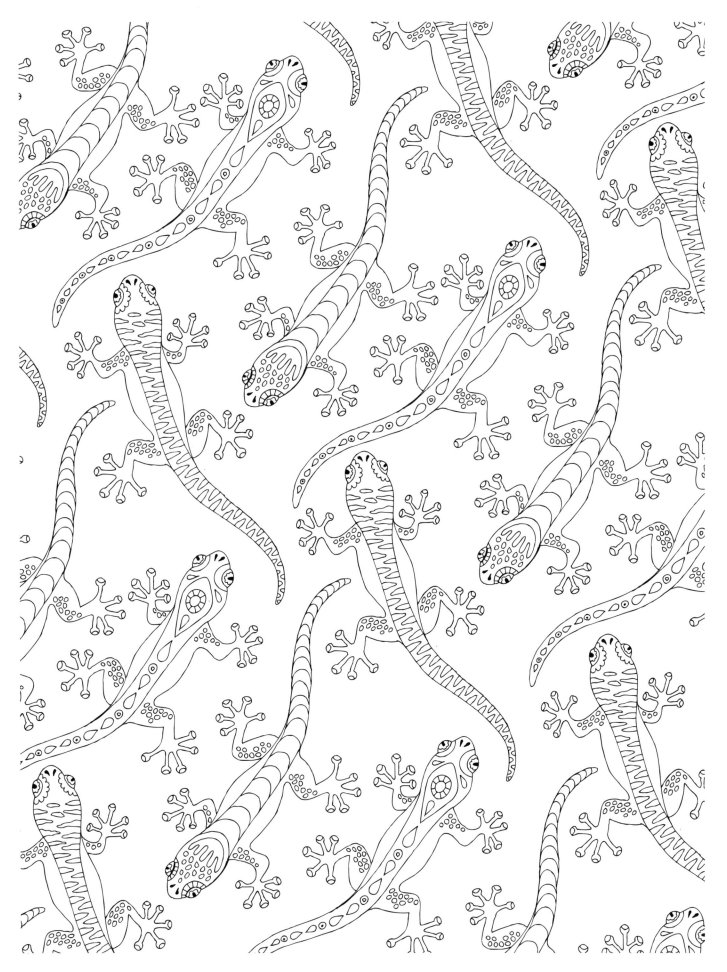

"Happiness doesn't depend
on any external conditions,
it is governed by
our mental attitude."

—DALE CARNEGIE

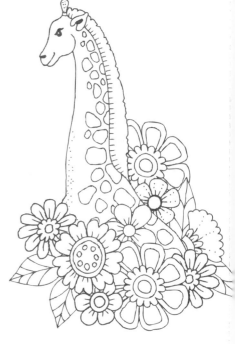

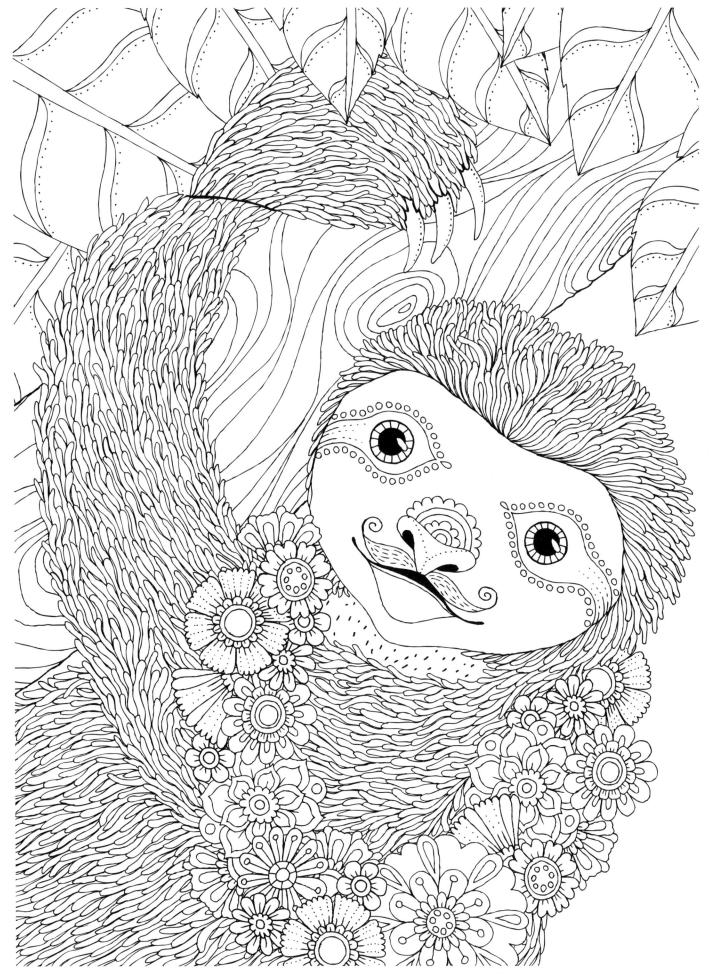

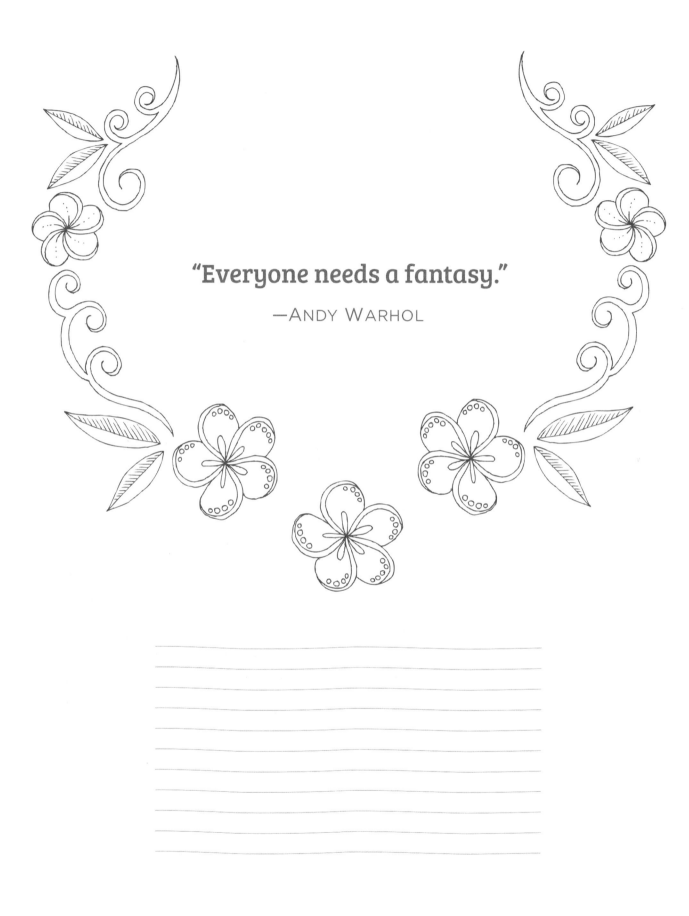

"Everyone needs a fantasy."

—ANDY WARHOL

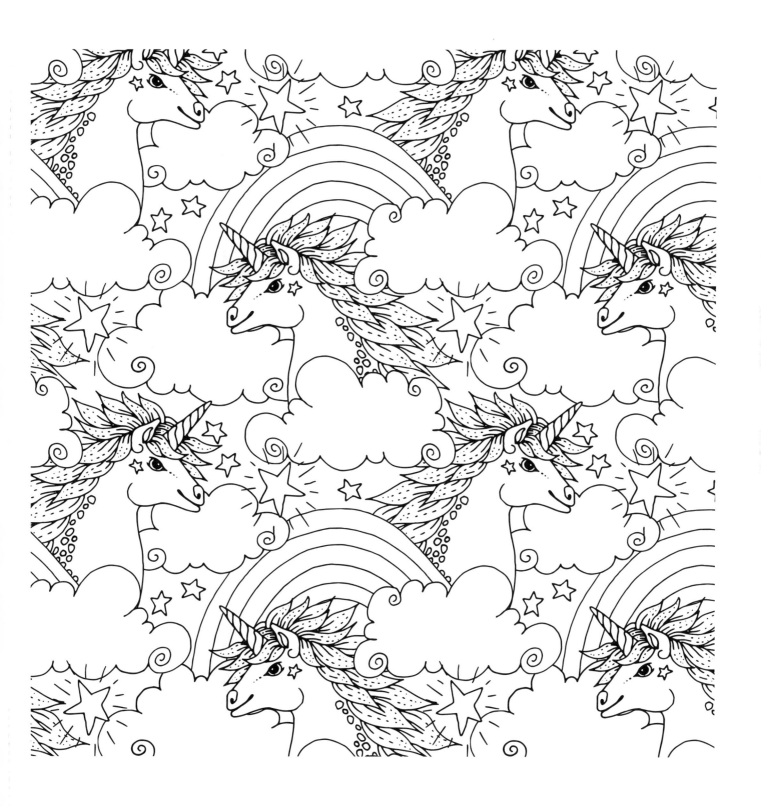

"Sometimes your joy
is the source of your smile,
but sometimes your smile
can be the source of your joy."

—THICH NHAT HANH

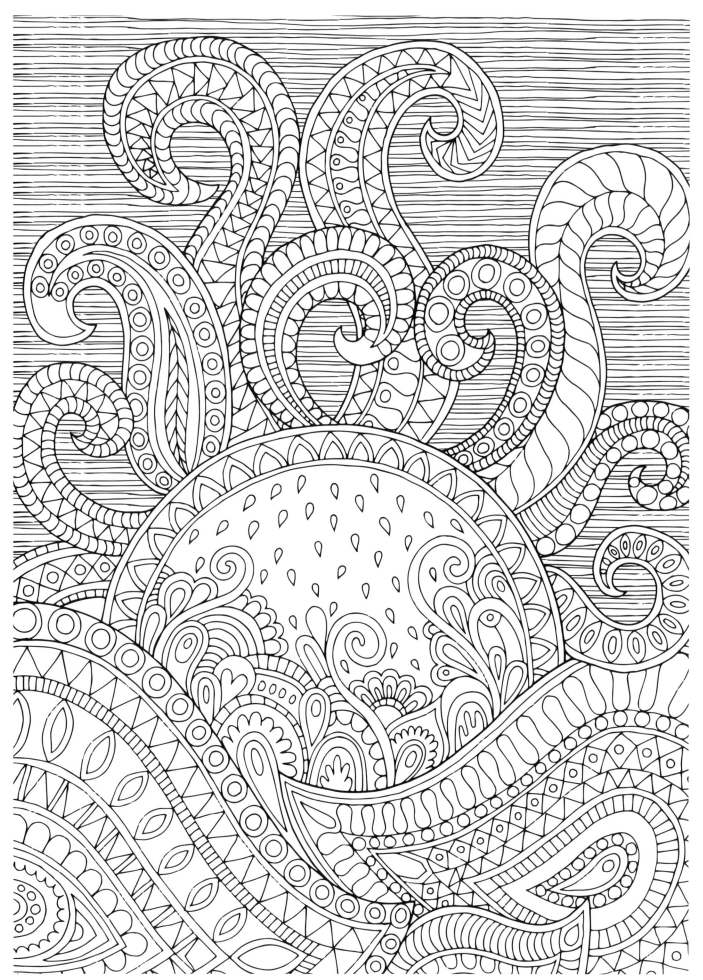

"Fantasy, abandoned by reason,
produces impossible monsters;
united with it, she is the mother of the arts
and the origin of marvels."

—FRANCISCO GOYA

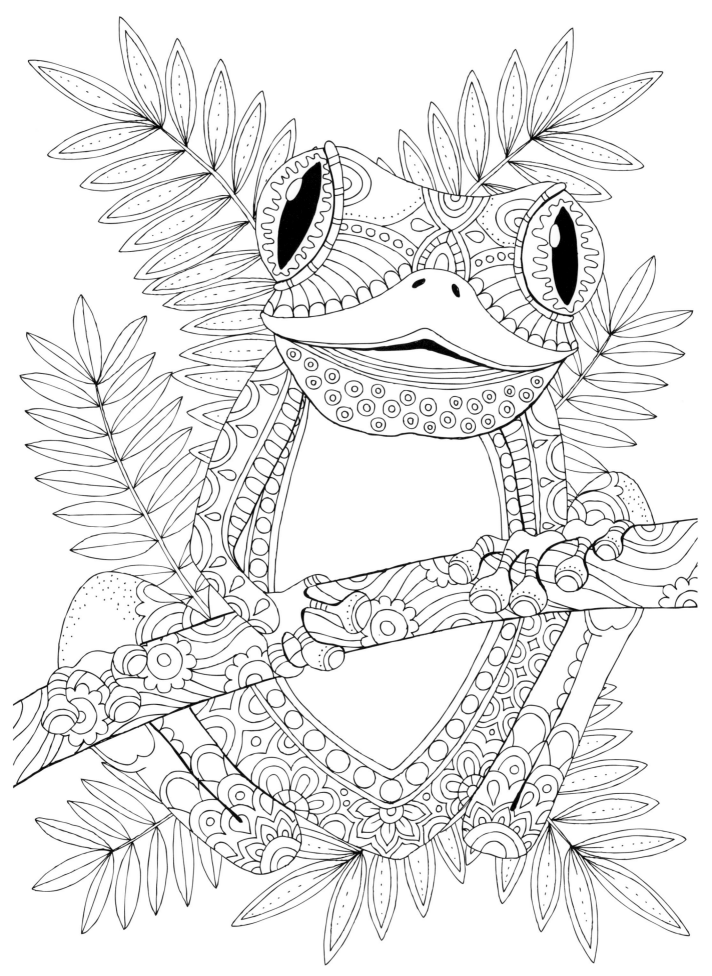

"Art is harmony parallel with nature."

—Paul Cezanne

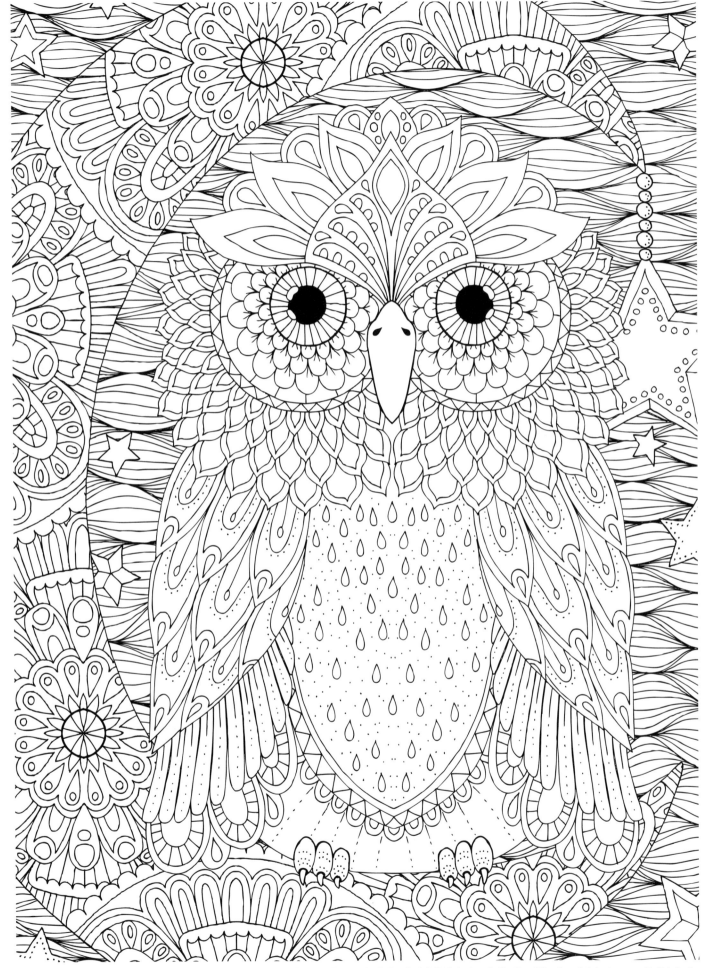

"Jump, and you will find out
how to unfold your wings
on the way down."

—RAY BRADBURY

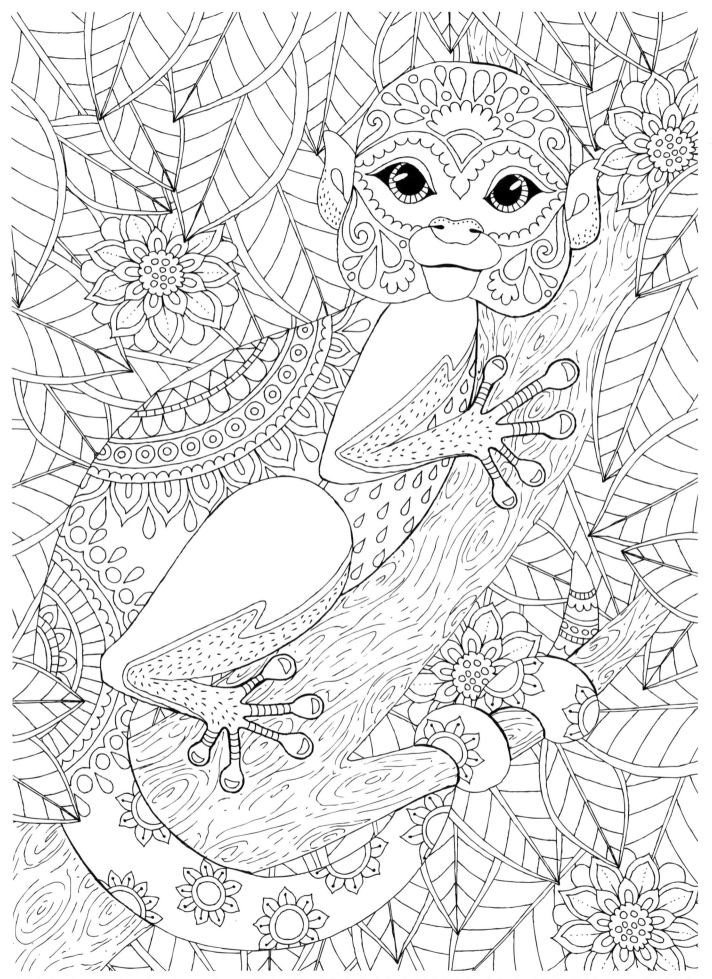

"A happy life must be to a great extent
a quiet life, for it is only in an atmosphere
of quiet that true joy dare live."

—BERTRAND RUSSELL

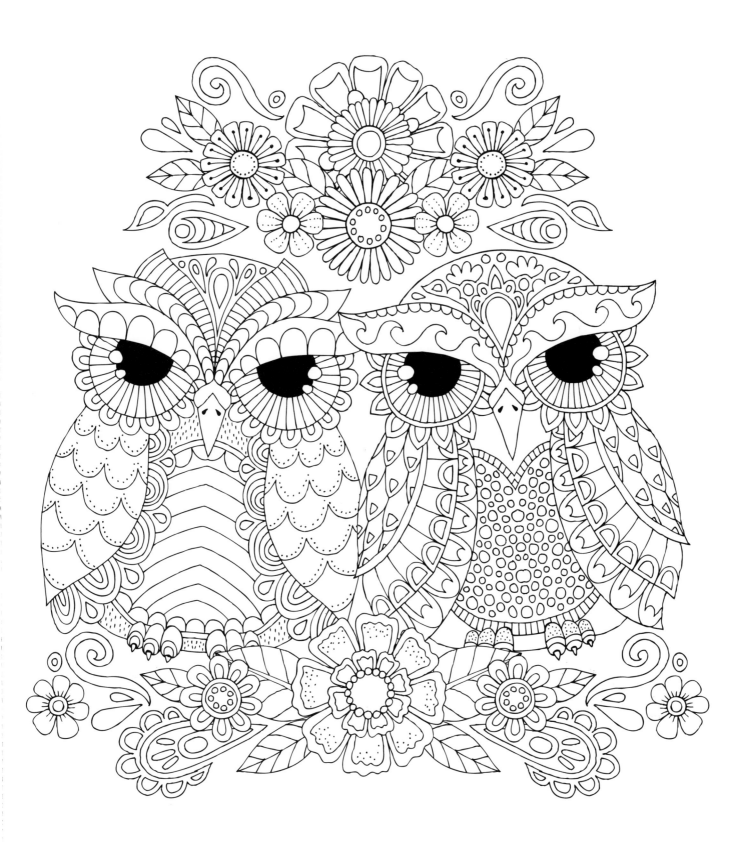

"I'm always astonished by a forest.
It makes me realize that the fantasy of nature
is much larger than my own fantasy."

—GÜNTER GRASS

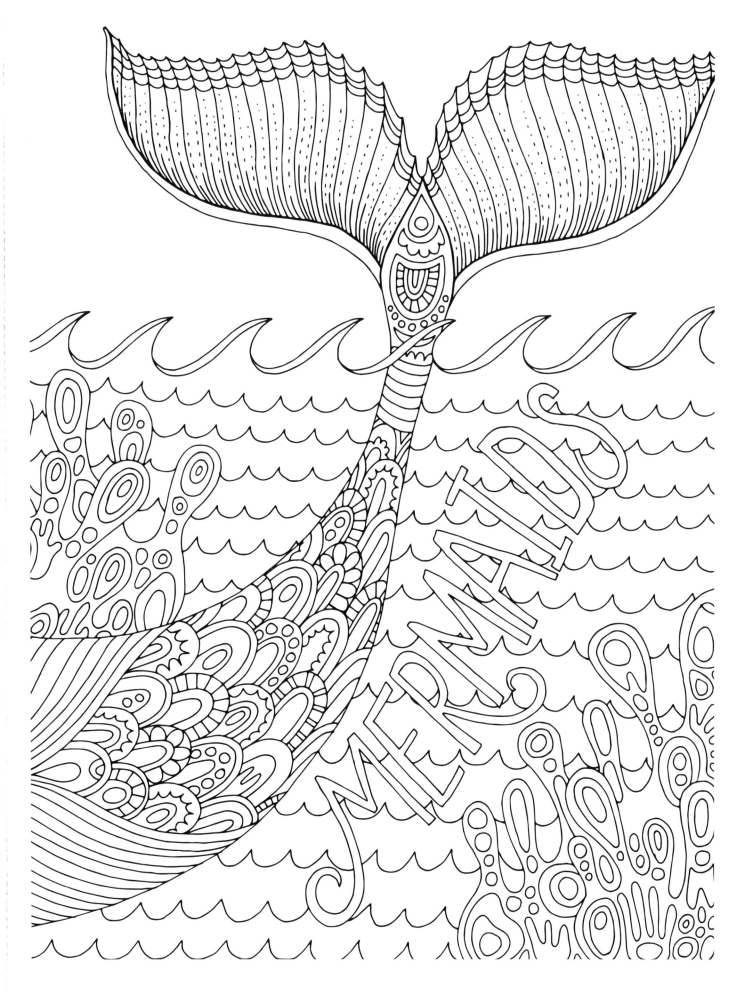

"A thing of beauty is a joy forever:
its loveliness increases;
it will never pass into nothingness."

—JOHN KEATS

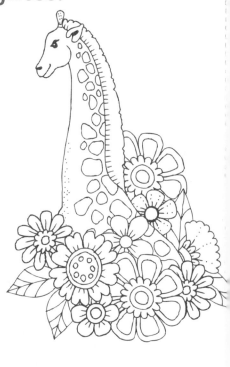

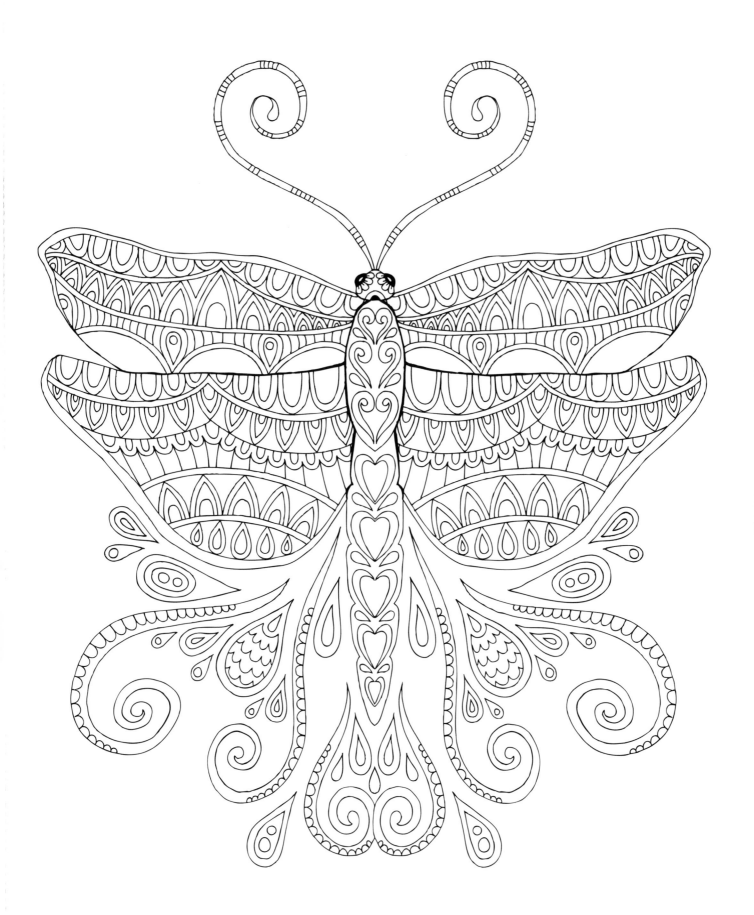

"Make an empty space in
any corner of your mind,
and creativity will instantly fill it."

—DEE HOCK

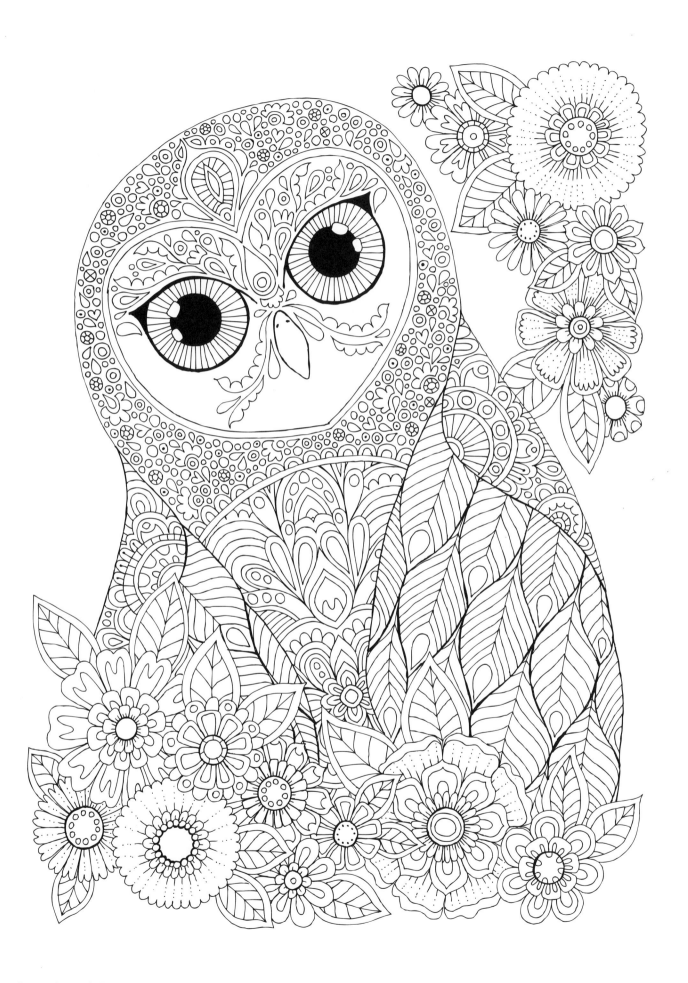

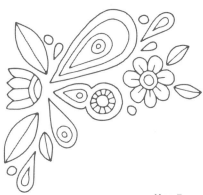

"The smallest seed of faith
is better than the largest
fruit of happiness."

—Henry David Thoreau

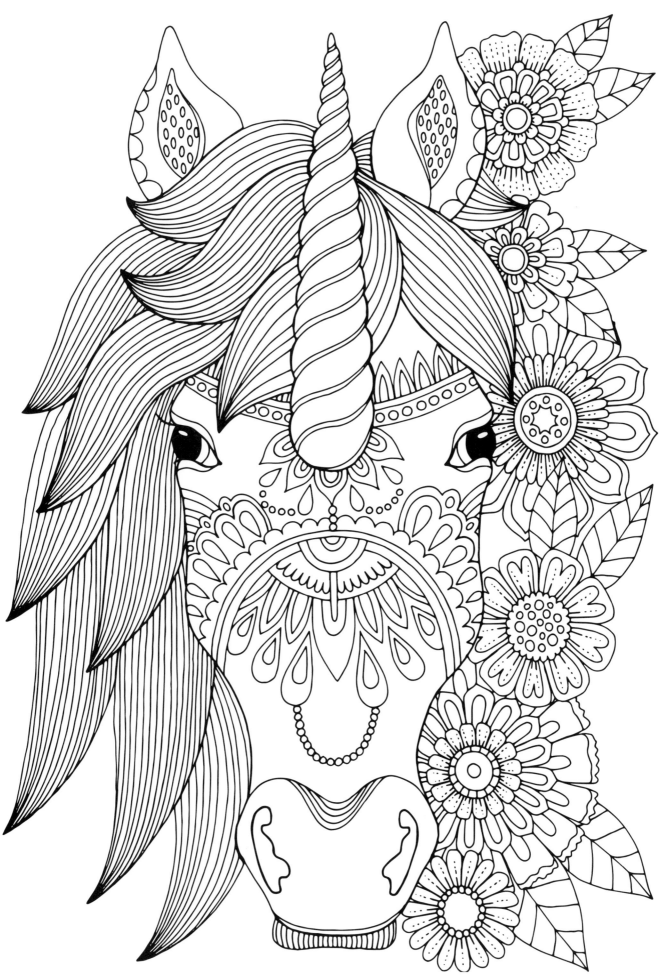

"I'm half living my life
between reality and fantasy at all times."

—LADY GAGA

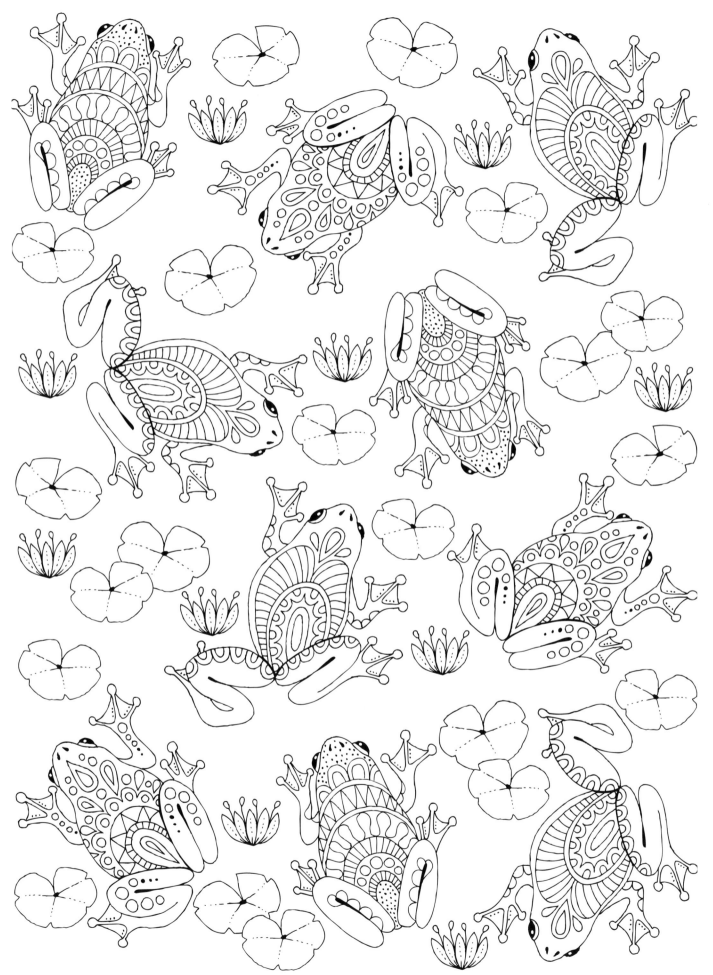

"Happiness is a thing to be practiced,
like the violin."

—JOHN LUBBOCK

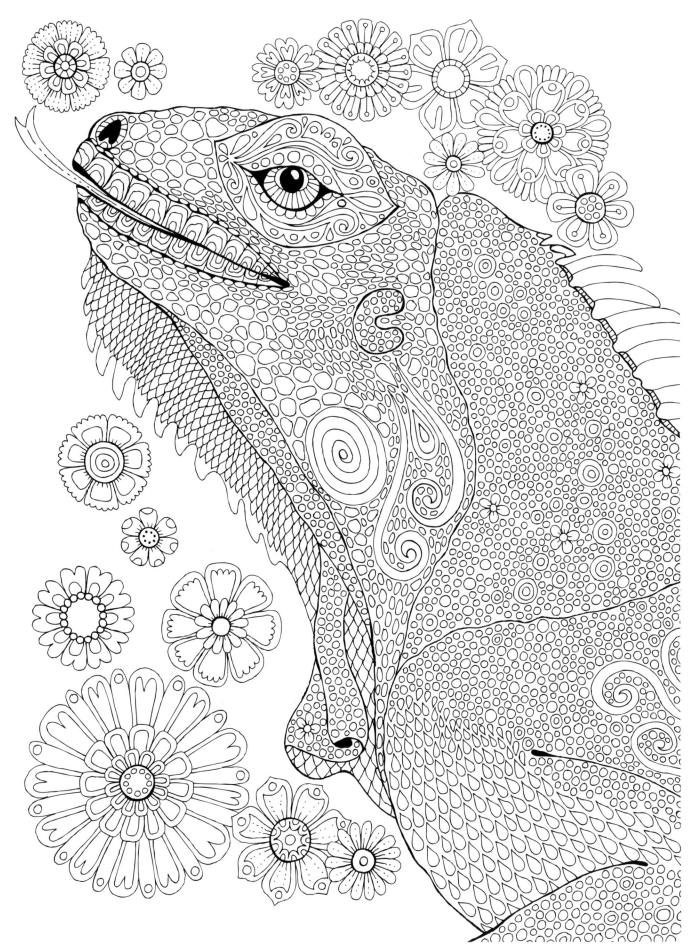

"Creativity is putting your imagination to work, and it's produced the most extraordinary results in human culture."

—Ken Robinson

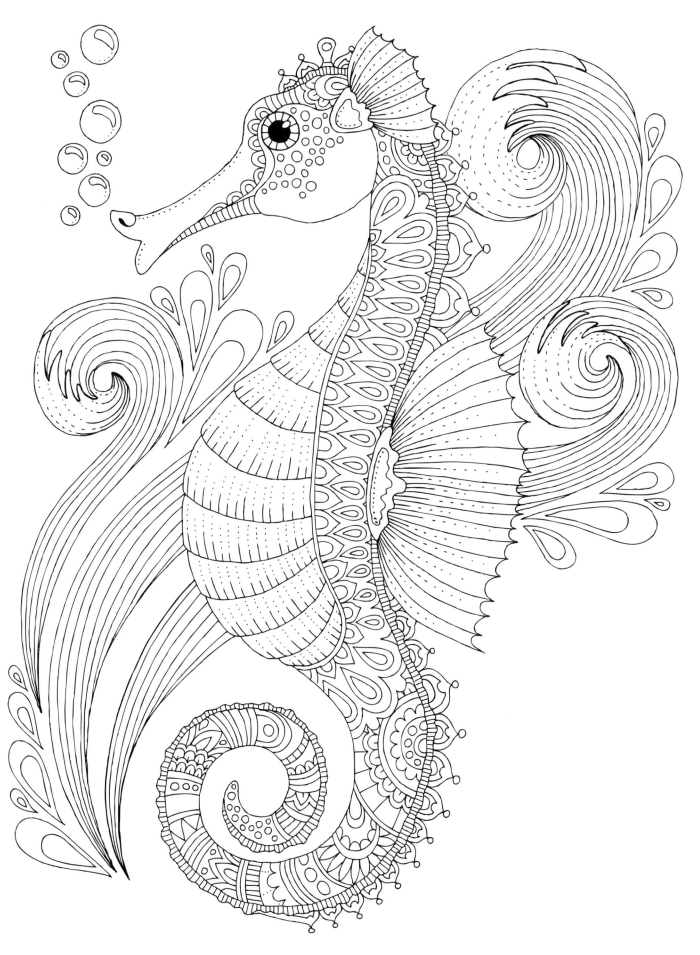

"My idea of absolute happiness
is to be in bed on a rainy day,
with my blankie, my cat, and my dog."

—Anne Lamott

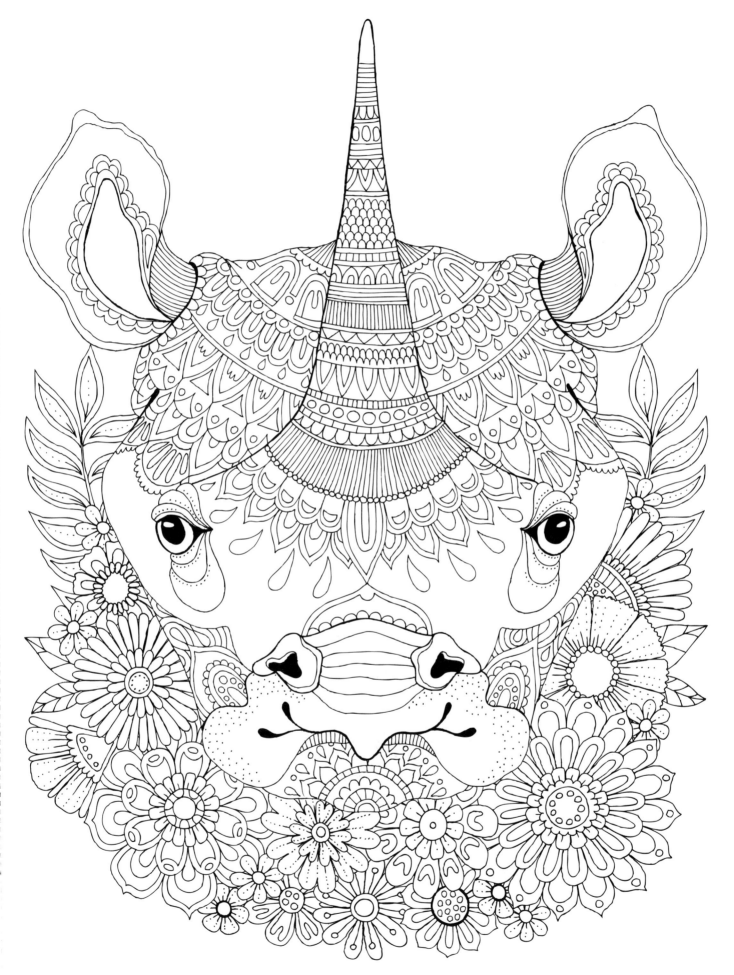

"We live in a fantasy world,
a world of illusion.
The great task in life
is to find reality."

—Iris Murdoch

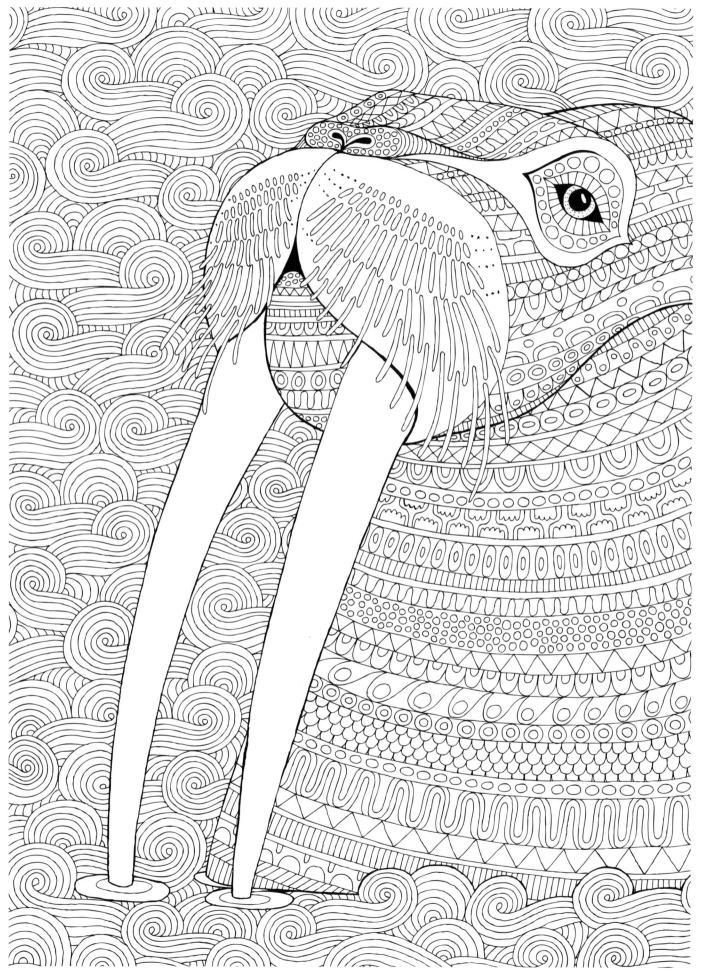

"Happiness is only real when shared."

—CHRISTOPHER MCCANDLESS

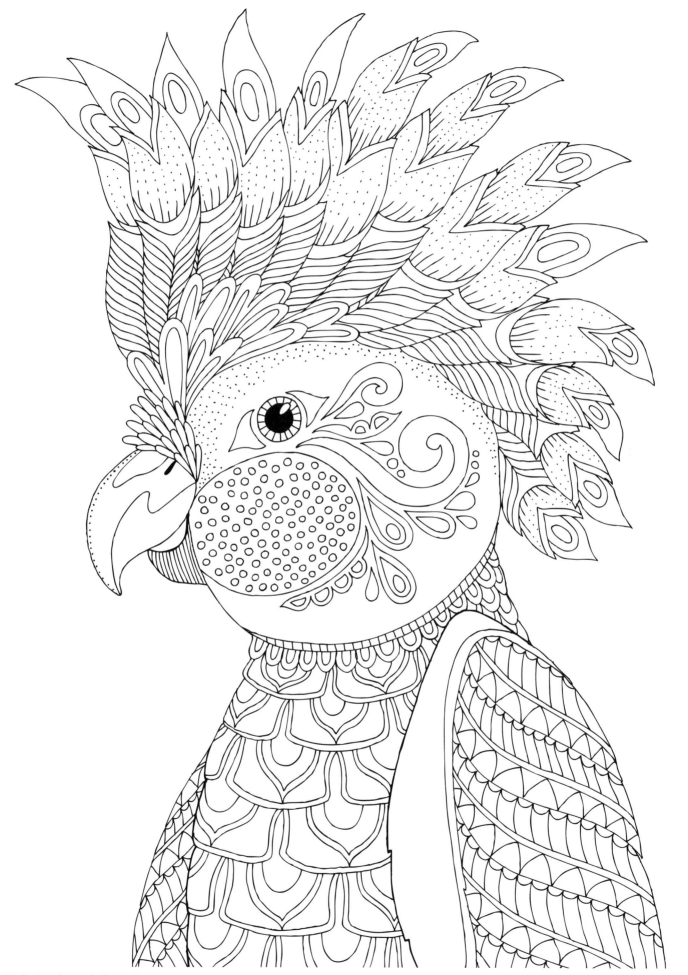

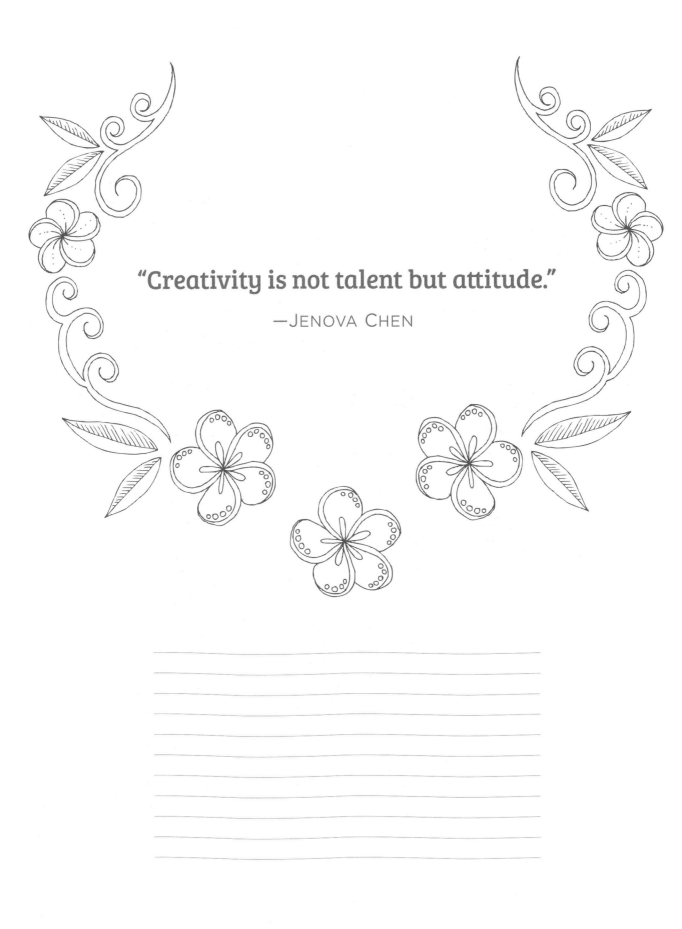

"Creativity is not talent but attitude."
—JENOVA CHEN

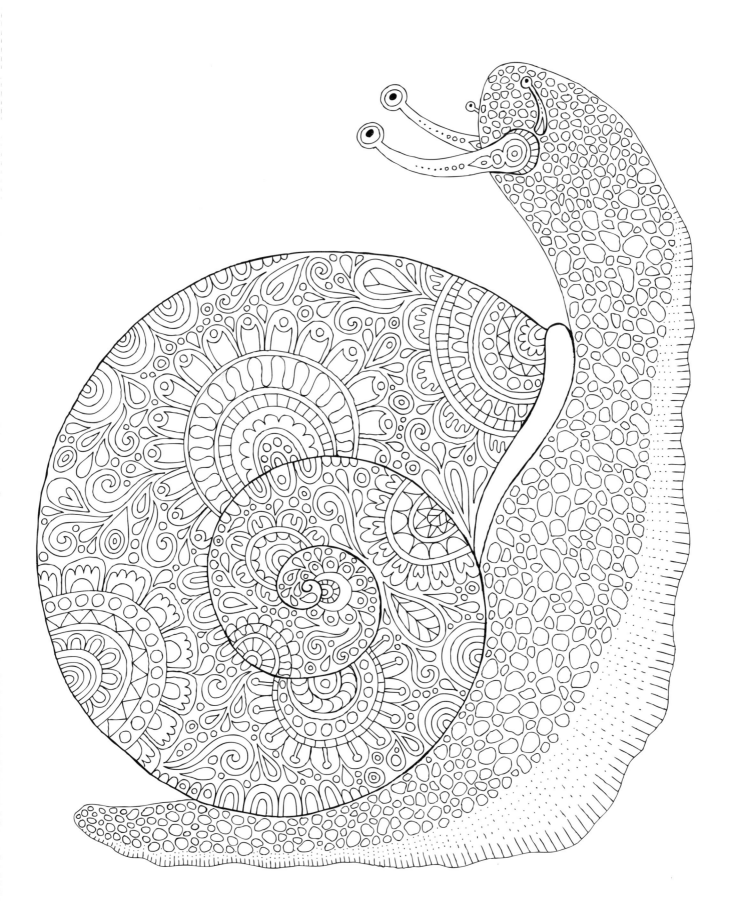

"You must enjoy the journey
because whether or not you get there,
you must have fun on the way."

—Kalpana Chawla

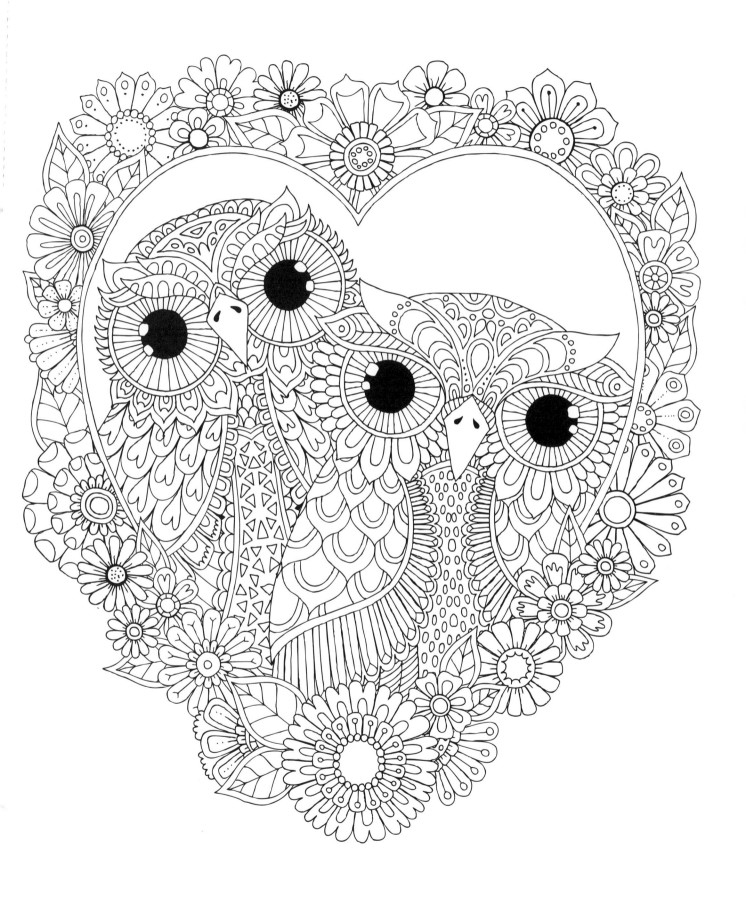

"Each generation imagines itself
to be more intelligent than the one
that went before it, and wiser than the one
that comes after it."

—George Orwell

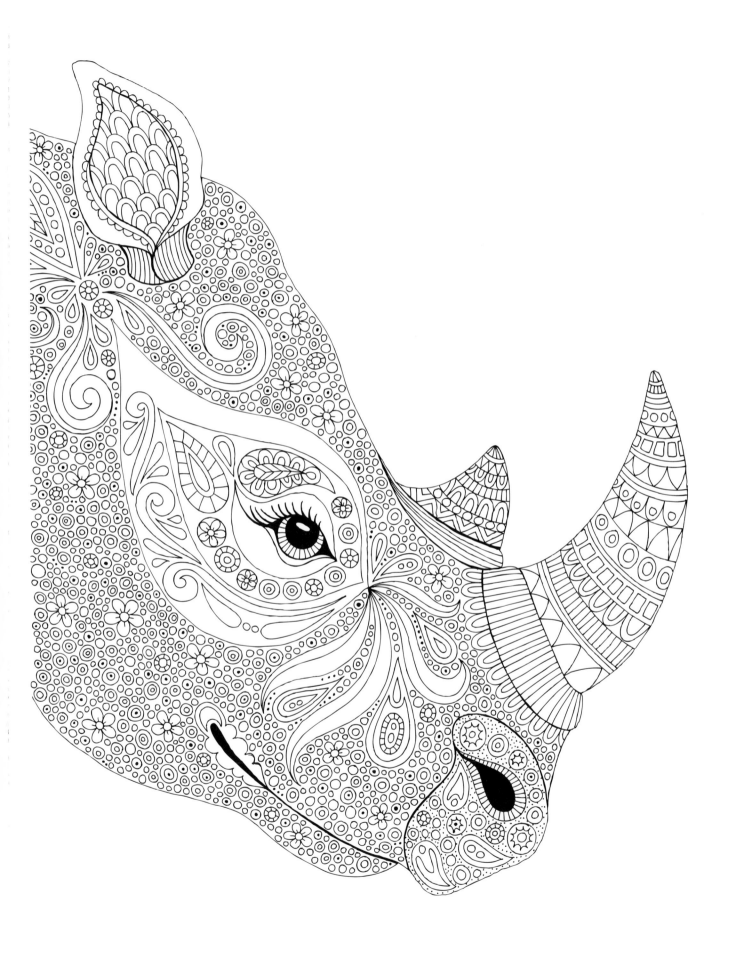

"Remember these two things:
play hard and have fun."

—TONY GWYNN

"But out of limitations comes creativity."

—Debbie Allen

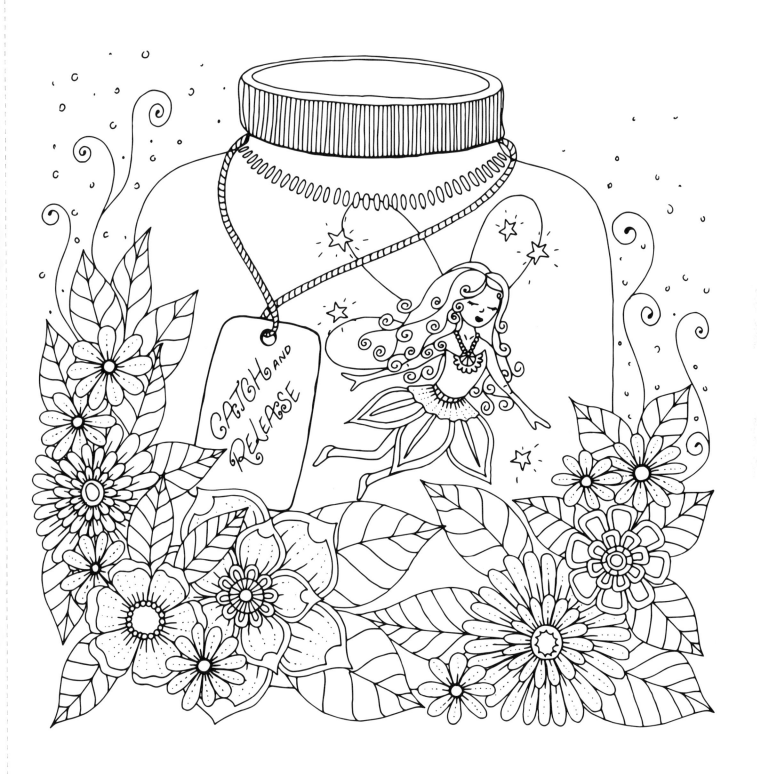

"There is little success where there is little laughter."

—ANDREW CARNEGIE

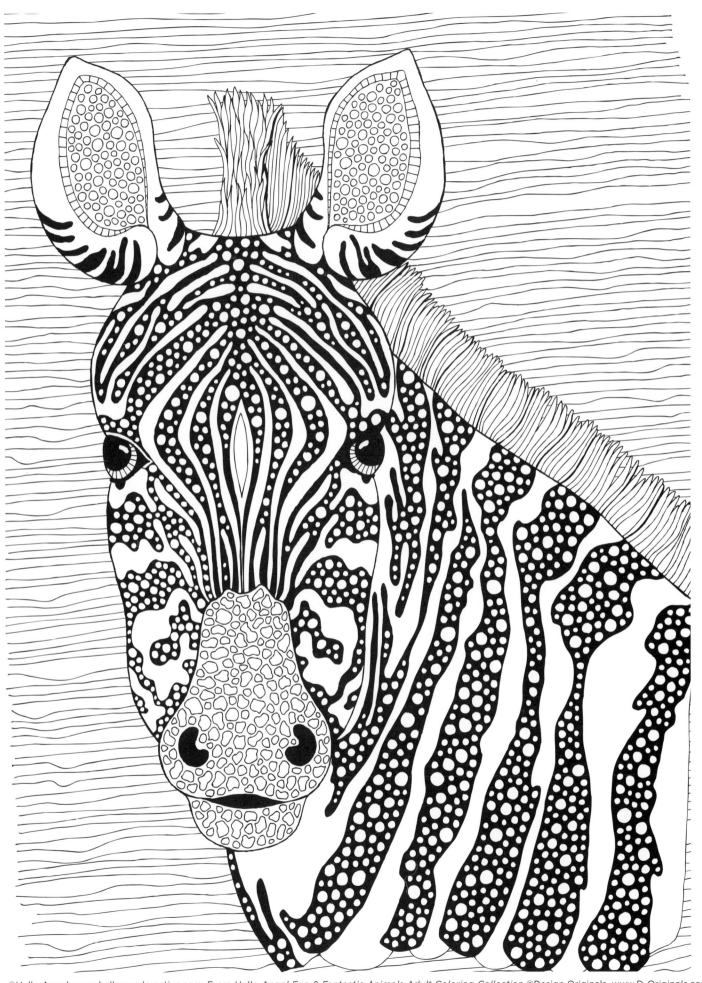

"The man who has no imagination has no wings."

—Muhammad Ali

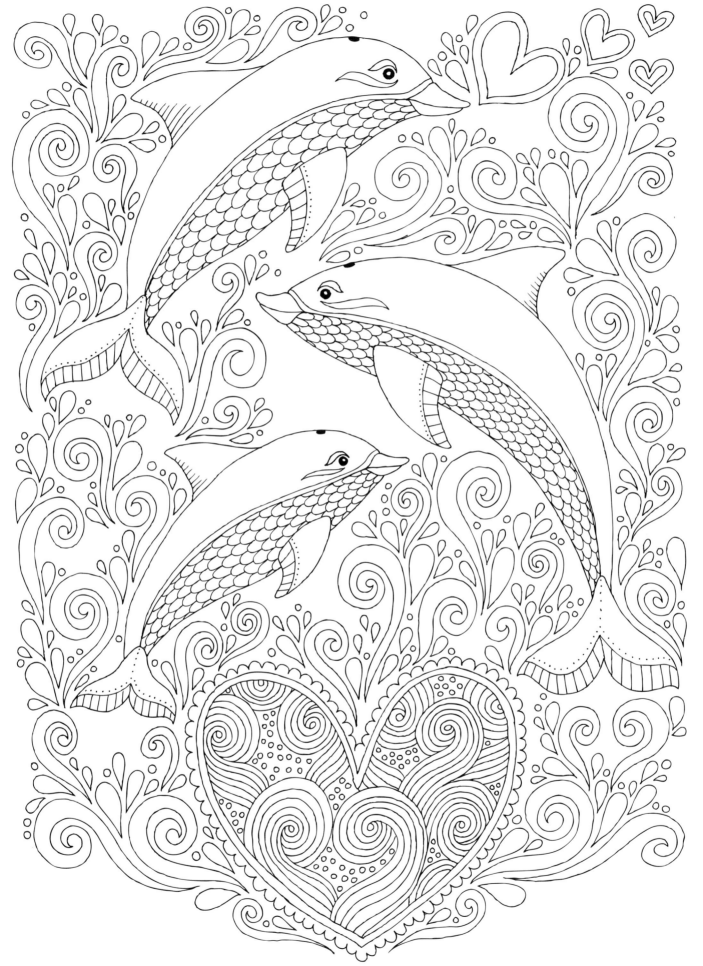

"Life is always going to be
stranger than fiction,
because fiction has to be convincing,
and life doesn't."

—Neil Gaiman

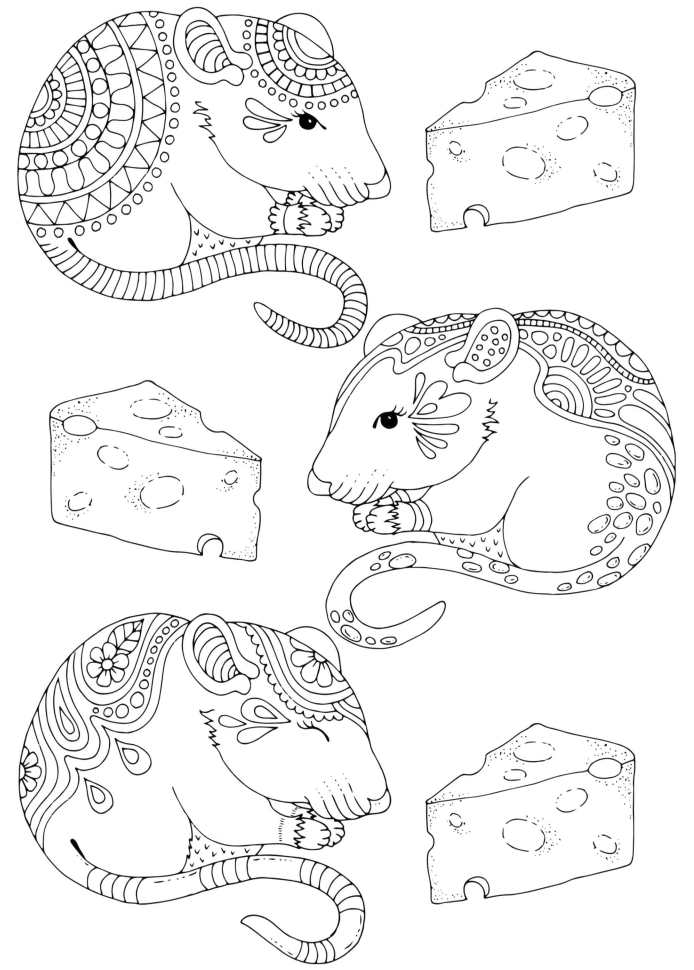

"Every great dream begins with a dreamer. Always remember, you have within you the strength, the patience, and the passion to reach for the stars to change the world."

—Harriet Tubman

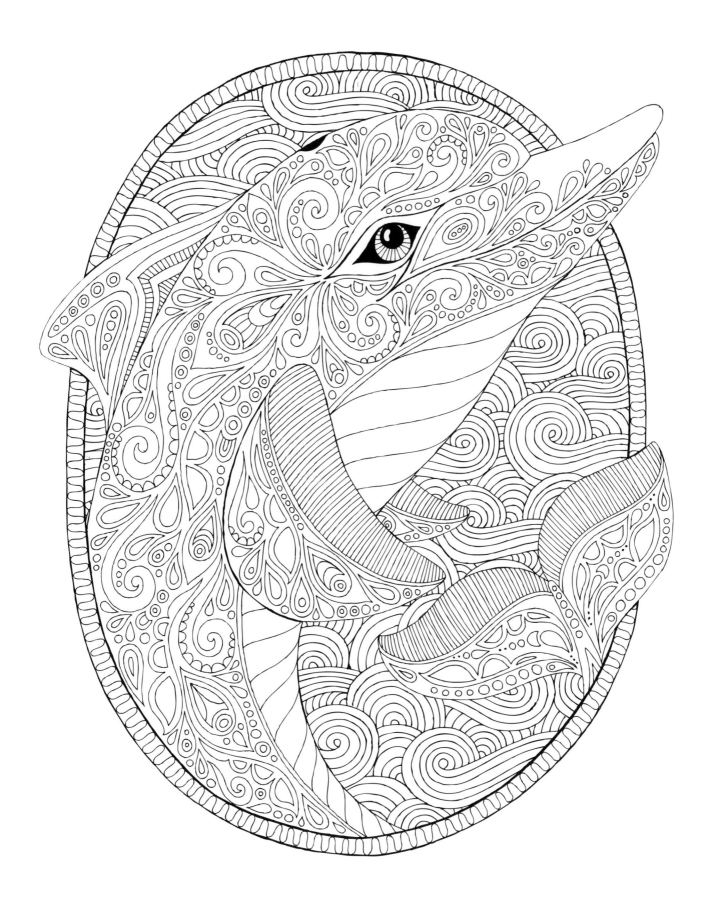

"Laughter is the closest
distance between two people."

—VICTOR BORGE

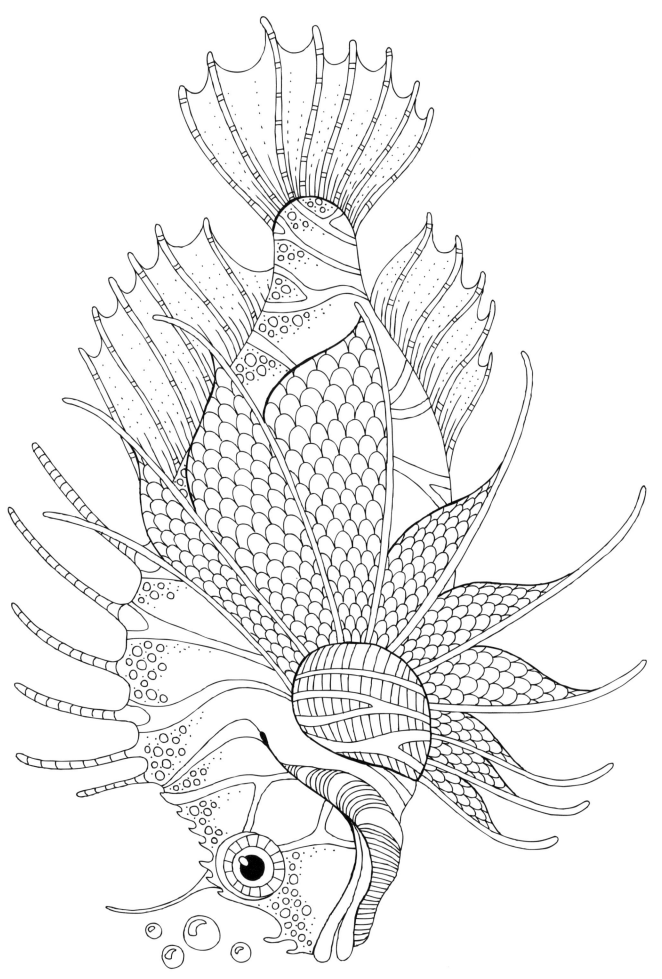

"Making the simple complicated is commonplace; making the complicated simple, awesomely simple, that's creativity."

—CHARLES MINGUS

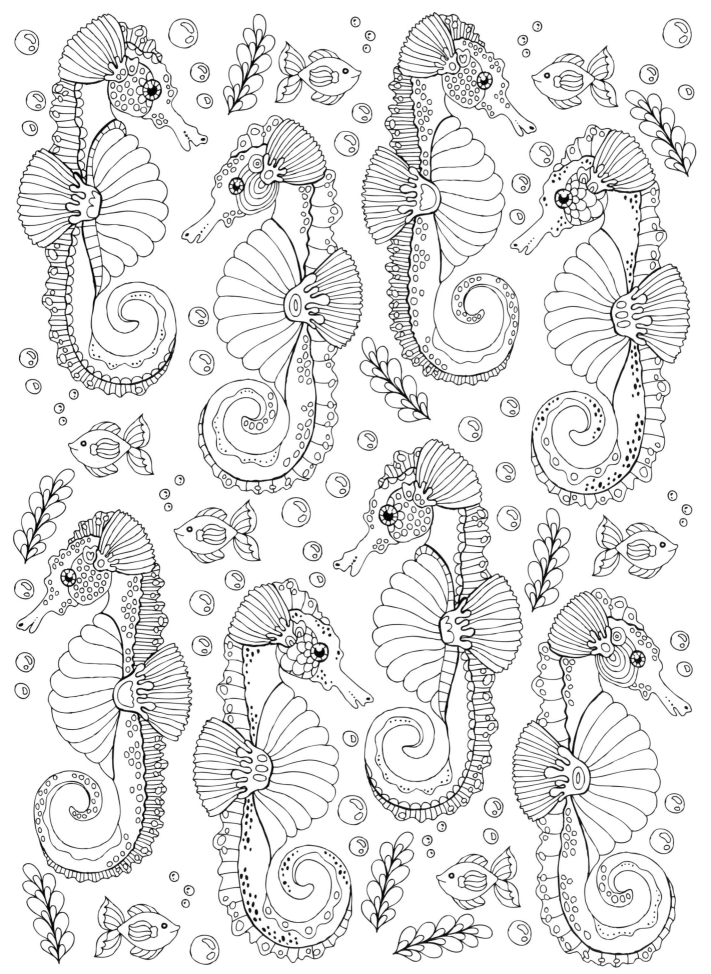

"In order to carry a positive
action we must develop here
a positive vision."

—Dalai Lama

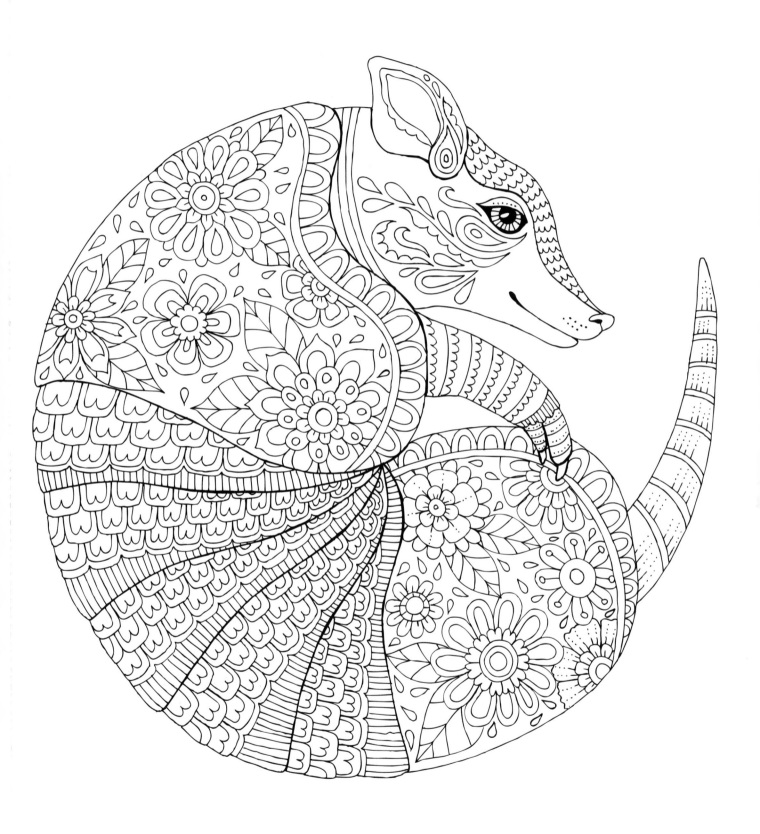

"The visionary starts with a
clean sheet of paper,
and re-imagines the world."

—Malcolm Gladwell

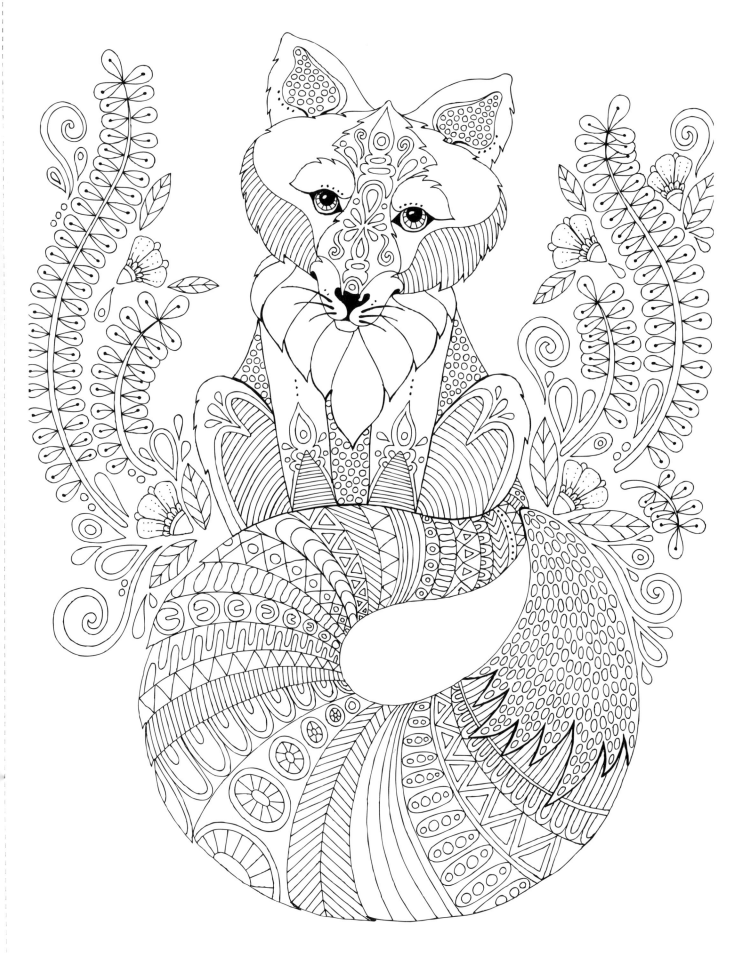

"She knew what all smart women knew: Laughter made you live better and longer."

—GAIL PARENT

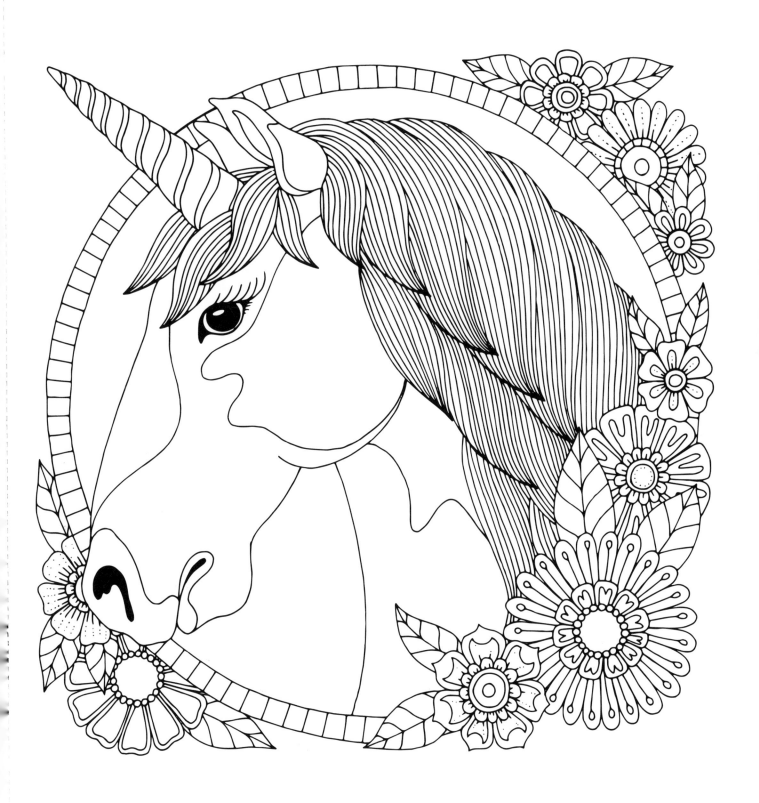

"There is no passion to be found playing small—in settling for a life that is less than the one you are capable of living."

—NELSON MANDELA

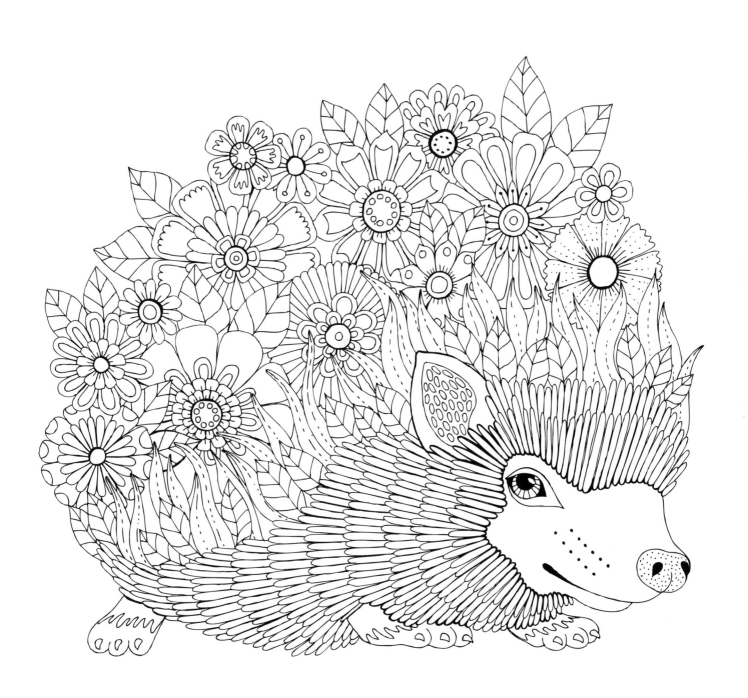

"Since you get more joy out of giving joy to others, you should put a good deal of thought into the happiness that you are able to give."

—ELEANOR ROOSEVELT

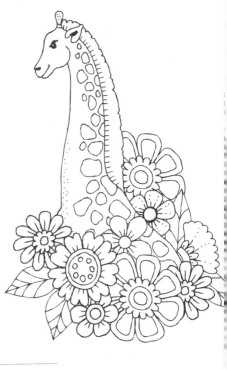

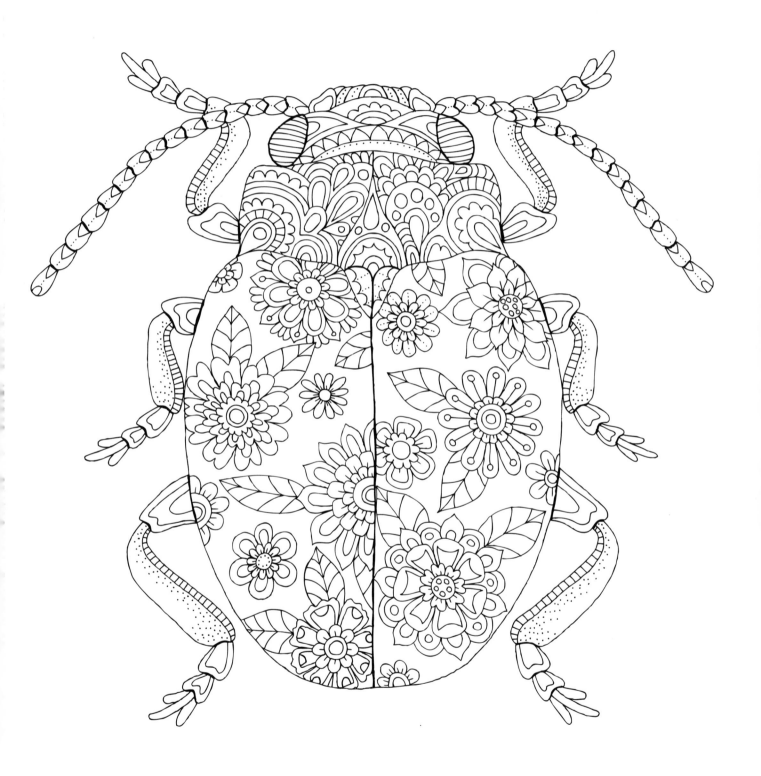

"It is good to have an end
to journey toward, but it is the journey
that matters in the end."

—URSULA K. LE GUIN

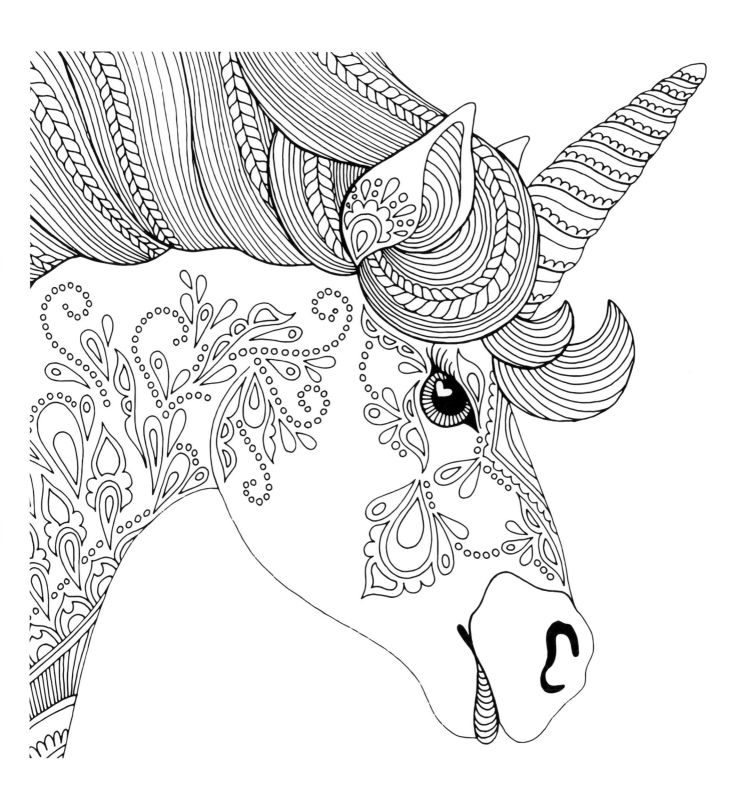

"Happiness is when what you think,
what you say, and what you do
are in harmony."

—Mahatma Gandhi

"No matter what people tell you,
words and ideas can change the world."

—DEAD POETS SOCIETY

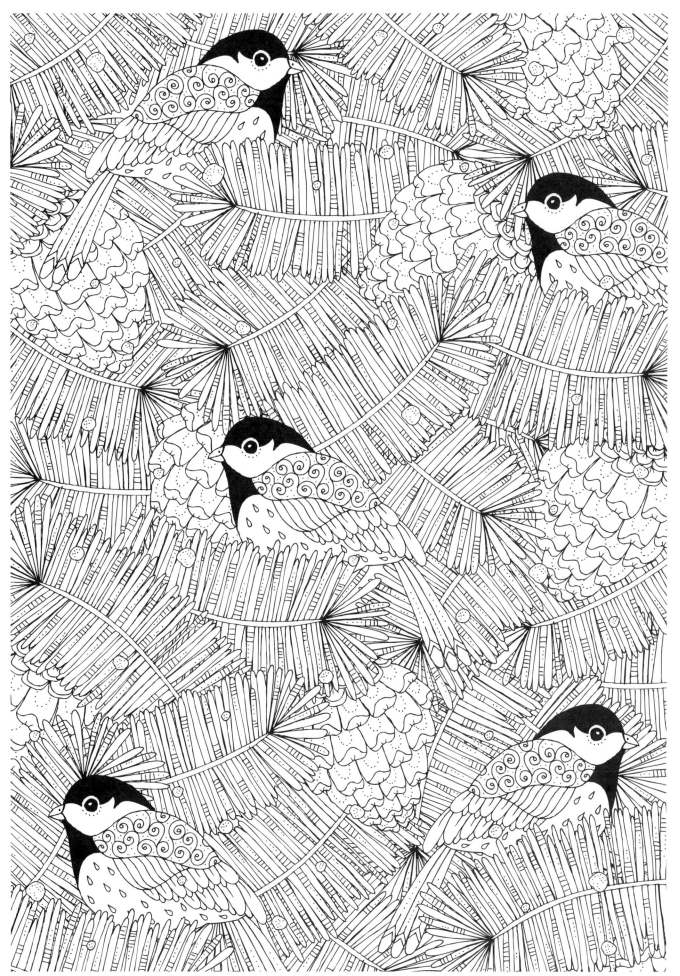

"Let your joy be in your journey—
not in some distant goal."

—TIM COOK

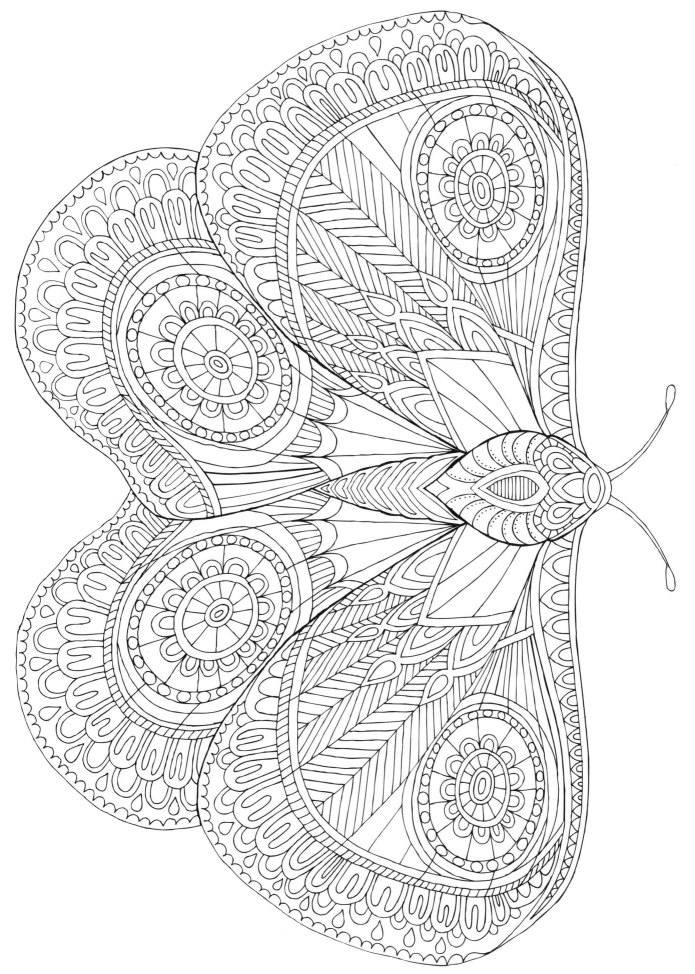

"Go out into the world with your passion and love for what you do, and just never give up."

—Dianne Reeves

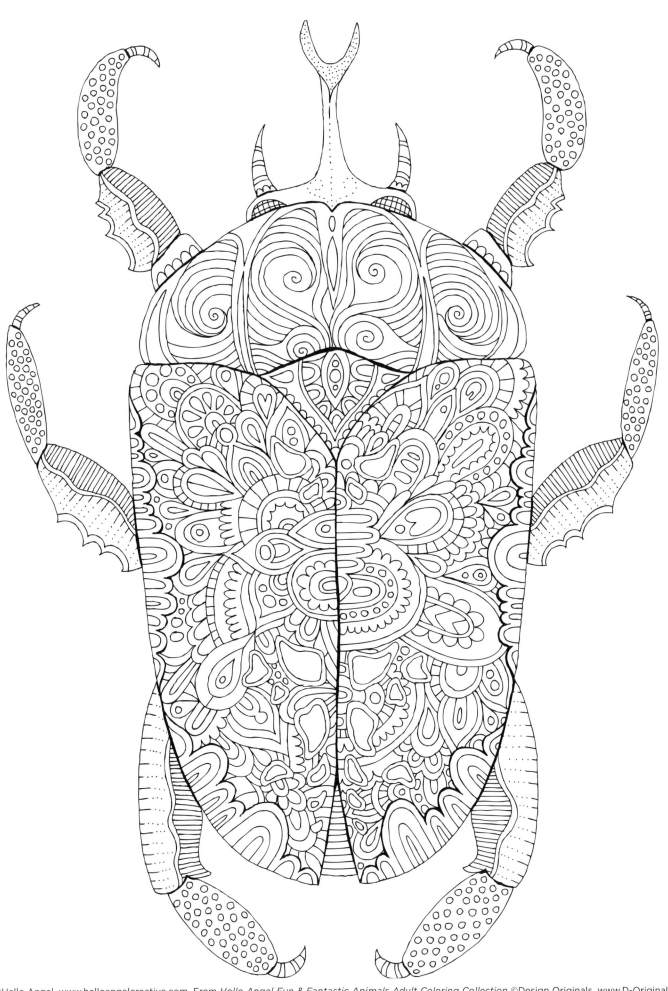

"Perfect happiness is a beautiful sunset, the giggle of a grandchild, the first snowfall. It's the little things that make happy moments, not the grand events. Joy comes in sips, not gulps."

—SHARON DRAPER

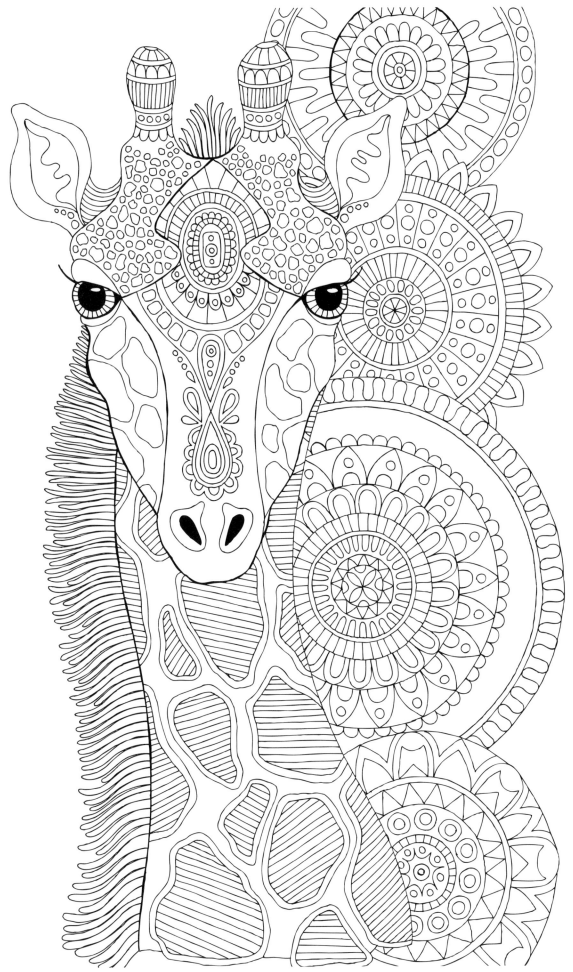

"What lies behind you and what lies in front of you, pales in comparison to what lies inside of you."

—Ralph Waldo Emerson

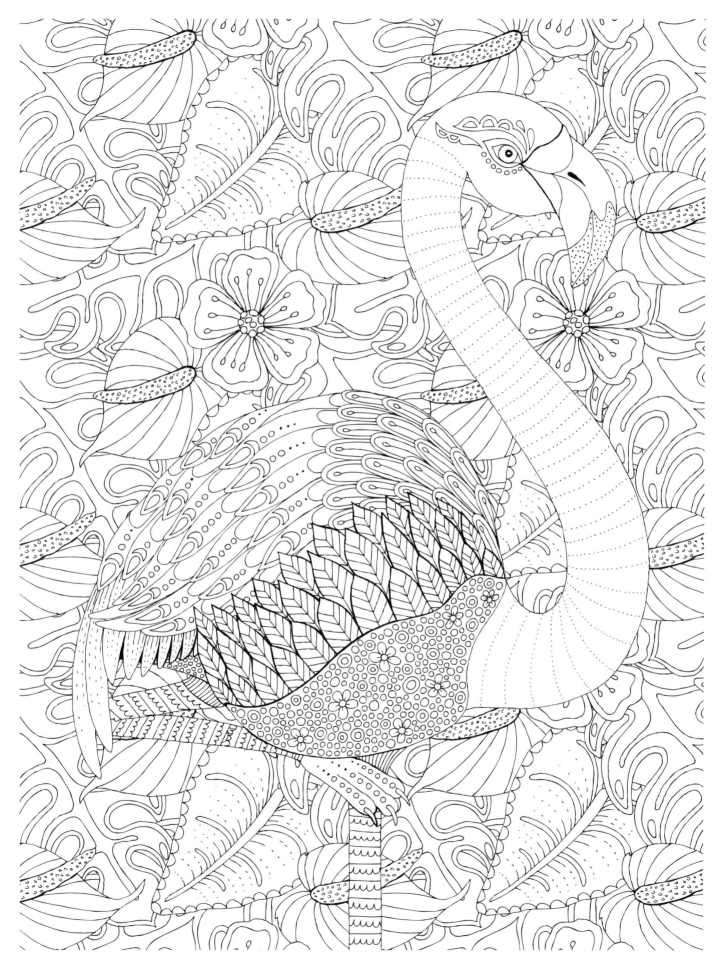

"Fantasy is a necessary ingredient in living, it's a way of looking at life through the wrong end of a telescope, and that enables you to laugh at life's realities."

—Dr. Seuss

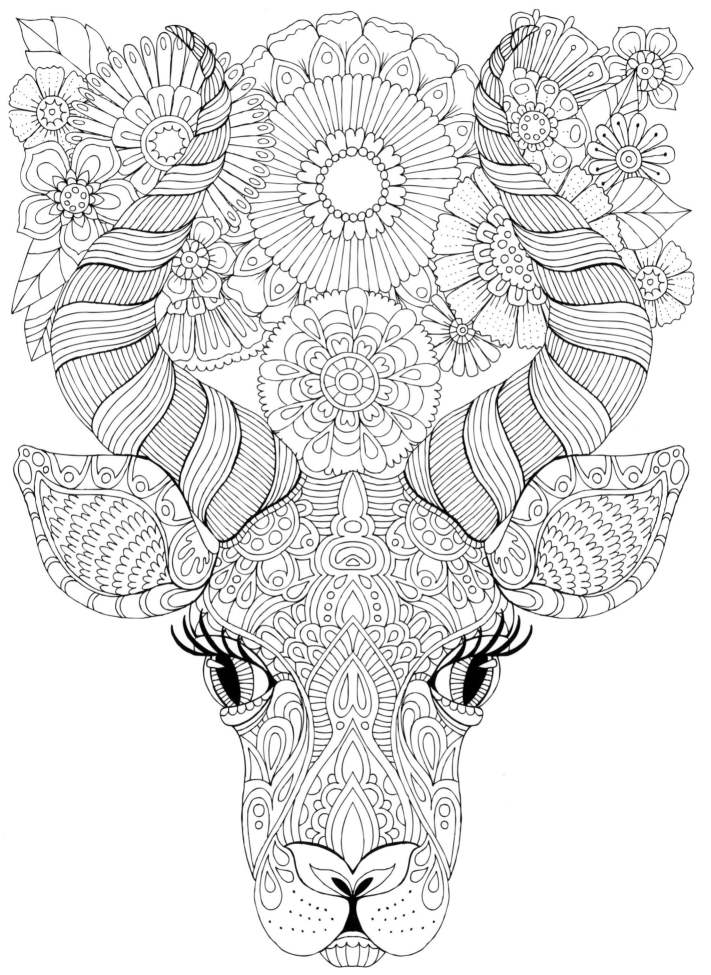

"All that is gold does not glitter, not all those who wander are lost; the old that is strong does not wither, deep roots are not reached by the frost."

—J.R.R. TOLKIEN